Rembrandt

GREG WATTS

Detail from Rembrandt's
1658 self-portrait.

HISTORY *makers* Illustrated

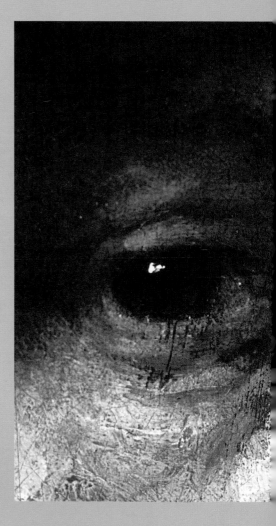

REMBRANDT

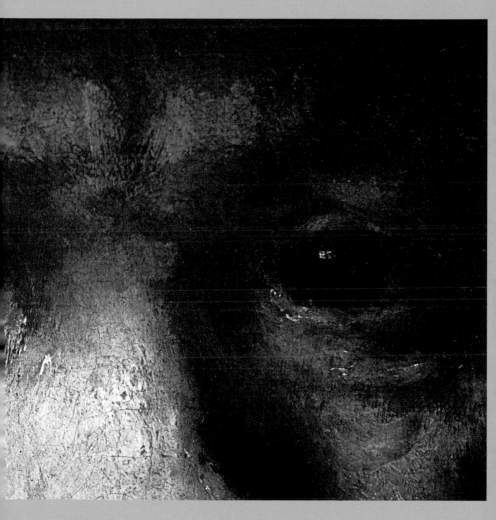

A Lion Book
an imprint of
Lion Hudson plc
Wilkinson House, Jordan Hill Road,
Oxford, OX2 8DR, England
www.lionhudson.com

ISBN 978 0 7459 5284 0 (UK)
ISBN 978 0 8254 7925 0 (US)

Distributed by:
UK: Marston Book Services, PO Box 269, Abingdon, Oxon, OX14 4YN
USA: Trafalgar Square Publishing, 814 N. Franklin Street, Chicago, IL 60610
USA Christian Market: Kregel Publications, PO Box 2607, Grand Rapids, MI 49501

First edition 2009
10 9 8 7 6 5 4 3 2 1 0

Typeset in 10/14pt Photina
Printed and bound in China

Contents

INTRODUCTION

I'd been to the National Gallery in London only a few weeks before and Betsy Wieseman, its enthusiastic curator of Dutch art, had talked me through its collection of Rembrandt's paintings. This time, as I threaded my way through the milling tourists in Trafalgar Square, I wanted to take another look at them, but alone, so that I could spend some time trying to understand what made Rembrandt such an outstanding artist.

Along with Michelangelo, Leonardo da Vinci, Monet, van Gogh and Picasso, he is one of those painters most people could name, even if they might be hard pressed to name one of his pictures. And quite a few people probably know that he was Dutch, although some might confuse him with his contemporary Vermeer, the subject of the book, and later movie, *Girl with a Pearl Earring*.

The National Gallery has one of the largest and most important Rembrandt collections in the world. The paintings hang in three rooms, alongside those of other Dutch masters from the seventeenth century, including Jacob van Ruisdael, Frans Hals and Gerrit van Honthorst.

As it was August, there were crowds of visitors, many from overseas, slowly winding their way around the rooms, pausing here and there, peering forward one moment, standing back the next. Some wore the headphones provided by the gallery to give a running commentary, which is available in eight languages including Spanish, Russian, Chinese and Japanese.

Two casually dressed women in their sixties stopped in front of *Belshazzar's Feast*, one of Rembrandt's most extraordinary and stunning pictures, painted when his star was rising in Amsterdam in the mid 1630s. Neither spoke for a moment. Each stood there in silence, privately drinking

in the incredibly rich colours and lifelike texture of the characters in the dramatic scene – taken, like a good many of Rembrandt's works, from the Old Testament. The woman in the white blouse said to her friend in an audible whisper, 'Look at the way that glows! Wow!'

When the two women inched along to the next painting, I stepped forward and stood in front of *Belshazzar's Feast*, and I felt exactly the same as they did. It is quite breathtaking, pulsating with life, drama and the supernatural.

The encounter between the natural and the supernatural is a theme that can be discerned in many of Rembrandt's biblical paintings from the beginning of his career in the 1620s to its end in 1669. This theme is at its most profound in another painting owned by the National Gallery, *Christ and the Woman Taken in Adultery*, done in 1644.

When I saw it for the first time, one of the things that struck me was how small it was. It looks tiny when compared to *Belshazzar's Feast*. Yet, despite its size, it is no less powerful. In a sense, the adulterous woman, whom Rembrandt portrays dressed in white and kneeling before Jesus, could be anyone facing up to the reality of the messiness and brokenness of their life. Yet, despite having transgressed the religious values of her time, she is depicted not in darkness but bathed in a divine light.

The National Gallery also contains two self-portraits by Rembrandt, painted twenty years apart, and revealing a man whose attitude to himself and life has changed radically in the intervening years. The first, painted in 1640 when he was at the peak of his career and the talk of the Amsterdam art scene, shows a 34-year-old who is brash, confident and pretty pleased with himself. More than that, he is trying to emulate similar self-portraits

> *Rembrandt was an 'aesthetic pioneer on the outer limits of seventeenth-century art'.*

by his heroes, Titian, Raphael and Rubens. In other words, he sees himself as their successor, part of the tradition of great masters.

In the second self-portrait, done in 1669, the last year of his life, we see a face that has tasted not just triumph but also disappointment and suffering. Yet we can see in him a wisdom and a dignity; he has come to terms with who he really is and what the true meaning of life is. Gone is the optimism and cockiness of the earlier, much lighter portrait. This is the face of a man who has lived.

Rembrandt was part of the Baroque movement in European art. Baroque paintings were characterized by movement, strong emotions, and dramatic lighting and colouring. This was a marked change from the balance and harmony that were the hallmarks of paintings from the Italian Renaissance, which looked back to the classical forms of ancient Greece and Rome for inspiration. As Leonard J. Slatkes, a former professor of art history at Queens College in New York, put it, Rembrandt was an 'aesthetic pioneer on the outer limits of seventeenth-century art'.

Rembrandt's paintings can be divided into four main categories: portraits, self-portraits, scenes from the Bible, and others such as mythological paintings and landscapes. He never painted the kind of homely interior domestic scenes in the realist style for which Johannes Vermeer became famous. Nor did he paint many of the kind of large-sky landscapes in which Jacob van Ruisdael specialized; and still lifes and maritime scenes never attracted him.

At the same time, some of Rembrandt's paintings don't fit neatly into any single category. He was innovative and liked to blur the boundaries. For example, *The Night Watch*, one of his most famous works, is a group

portrait, commissioned by one of the civic militia units in Amsterdam. Yet it can also be seen as a historical painting.

In some cases, historians are divided as to whom the subjects are meant to represent. An example of this is *St Bartholomew Holding a Knife*, one of a series of paintings Rembrandt did of the twelve apostles of Jesus in the late 1650s. An eighteenth-century English artist, Charles Phillips, made an engraving of the painting under the title *The Assassin*, presumably because the figure was holding a knife. In the nineteenth century some art historians retitled the painting *Rembrandt's Cook*. Later, a French historian claimed that the figure was neither a saint, an assassin nor a cook but a surgeon. Today, experts agree that the figure is indeed St Bartholomew, who was martyred by being flayed with a knife.

E. H. Gombrich, author of *The Story of Art*, one of the classic introductions to painting, suggests that people feel more of an affinity with Rembrandt than with any of the other great masters such as Michelangelo, Leonardo or Rubens. He suggests that this is because Rembrandt left 'a unique autobiography' in the form of a series of self-portraits painted throughout his life.

But the real appeal of Rembrandt goes much deeper for many of those who flock to galleries around the world to stare and to ponder in front of his works. This is because, argues the great historian Kenneth Clark, Rembrandt felt a responsibility to explore the moral and spiritual condition of man. 'He was alone with his experience of human life, which he had to lift on to a spiritual plane without any sacrifice of truth, and with no other guidance than the words of the Bible.' Rembrandt, he goes on to suggest, 'digs down to the roots of life'.

Rembrandt was born into a Christian culture, and his Christian beliefs shaped his world-view and how he saw people. In other words, he believed that there was a meaning to life and there were answers to the big questions. The Bible provided him with the narrative of the human race: its fall from grace in the Garden of Eden, its fumblings toward God through the people of Israel, the entry of the divine into human life in Jesus Christ and the redemption of all that he brought about through his crucifixion and resurrection.

Rembrandt's ability to penetrate what it is to be human transcends religious boundaries, and people of all faiths or no faith can be moved by it. In this respect, he is like all great artists, poets, writers and musicians. They almost seem to be simple vehicles for something greater than themselves.

THE MAN

We actually know very little about Rembrandt's life, about the man behind the name. He wrote no books about his paintings and only left behind seven letters, all relating to some difficulties he was having completing, and getting paid for, a series of paintings commissioned by Prince Frederik Hendrik, the governor or *stadholder* of five Dutch provinces. There are some references to him in legal documents and we can pick up a few scraps of information from several seventeenth-century biographers and one from the early eighteenth century. Jan Orlers provides a thumbnail sketch of him in 1641 in his book about Leiden. Later, Joachim von Sandrart, a German artist, mentions him in 1675, Filippo Baldinucci in 1686, and in 1718, Arnold Houbraken.

At one time, biographers presented an image of Rembrandt as an ignorant boy from Leiden who became a lonely, misunderstood genius, and whose glittering career as a painter crashed spectacularly after his picture *The Night Watch* was rejected by the civic officials who had commissioned it. After this, he went bankrupt; languished on the margins of Amsterdam society, painting nothing significant; and eventually died in obscurity and poverty.

This account is a long way from the truth. Rembrandt might not have travelled outside the Netherlands, and it is true that he hadn't seen the works of the masters in Italy, but he was far from ignorant. He not only knew the Bible from back to front but also had a wide knowledge of Greek and Roman mythology. And he learned a lot by simply observing the people he saw in the streets of Amsterdam. He interiorized their expressions, their gestures and their movements, and the design, colour and texture of their clothes. He missed nothing.

To build up a picture of his life, we have to look at his works and at the society he lived in. He was not just a painter. He was also a marvellous draughtsman and etcher. And he was prolific. Taken together, his paintings, drawings and etchings offer many clues to what he was like, what he was interested in, how he saw the world and what drove him, especially when he ran into troubles in his personal life or with money.

So much praise is often heaped upon Rembrandt's brilliance as an artist that it is easy to overlook the fact that he was a commercial painter trying to appeal to the tastes of the market and earn a living. And money troubles plagued him for much of his life. Like many creative people, he seems not to have been very good at managing his finances. This poor grip on money matters led him to court and nearly ruined him.

Rembrandt lived in the middle of an extraordinary flowering of art in the Netherlands. It is thought by experts that somewhere between two and three million paintings were produced in this small corner of northern Europe during Rembrandt's lifetime. Only in Renaissance Italy, which gave us such works as Michelangelo's *The Last Judgment* and Leonardo da Vinci's *The Last Supper*, had there been a comparable explosion of talent. For so many great artists to be born in the same place at the same time is rare. This didn't happen again until the nineteenth century, when artists such as Monet, Manet and Renoir created the Impressionist movement in France.

The seven provinces of the northern Netherlands that had broken free from Spanish rule to form the United Provinces were undergoing a period of economic prosperity and national self-confidence. The commissioning or buying of paintings became very popular among the Dutch people, particularly the wealthy merchants. It's probably true to say that we know more about what the people of the Netherlands in the seventeenth century looked liked and how they lived than about any other nation of the time. In a podcast interview to coincide with an exhibition entitled 'The Age of Rembrandt' at the Metropolitan Museum of Art in New York, Walter Liedtke, the museum's curator of European paintings, talked about how Vermeer presented an idealized image of domestic life in the seventeenth-century Netherlands which ties in with its prosperity and new pride as an independent country, what he describes as the Dutch equivalent of '*Vogue* meets *Architectural Digest*'.

Although the Dutch sailed to the four corners of the world in search of new trade opportunities, and many artists were heading south to Italy to study the work of masters such as Michelangelo, Titian and Leonardo da

Vinci, Rembrandt never travelled beyond the Netherlands. He preferred to stay at home.

Perhaps one of the main appeals of Rembrandt in the twenty-first century is, as Walter Liedtke suggests, that his paintings seem familiar to us while at the same time presenting an ideal from another age. 'Modern life is so much about frantic moving,' Liedtke says, but when 'modern people... look at a Rembrandt or a Vermeer' it puts them in touch with an older and more relaxed way of life.

There is no single meaning to a painting. Different things will strike different people: the mood it conjures up, a character or an object, the use of colour, the texture or intricate detail. In some cases it is hard to pin down exactly what it is about a particular painting that you like. There's just something about it, whatever that something is.

Despite all his personal anguish, misfortune and struggles, Rembrandt never lost his ability to see beyond appearances and into another world. That's why, 400 years later, he is regarded as one of the greatest artists who ever lived.

Chapter 1
LEIDEN

S tanding on the banks of the Old Rhine, a tributary of the Rhine, and surrounded by flat countryside stretching as far as the eye can see, the walled medieval town of Leiden was, like Paris and Oxford, one of the great centres of learning in the seventeenth century. The seat of the first university in the northern Netherlands, Leiden had a reputation as a place of knowledge and ideas that attracted students from much of north-western Europe. They mingled with the locals in the narrow streets that ran along the town's network of canals, creating a cosmopolitan and vibrant atmosphere.

It was in Leiden that Rembrandt Harmenszoon van Rijn was born. Most scholars place his birth on 15 July 1606. As with much of Rembrandt's life, there is disagreement over what we can know for sure. But we do know that his father, Harmen Gerritszoon van Rijn, came from a family of millers (named after the River Rhine) and his mother, Neeltgen Willemsdochter van Zuytbroeck, from a family of bakers. They married at the town's Peterskerk in 1589 when they were both aged twenty-one. Rembrandt was the ninth of their ten children and was born when they were both thirty-eight years old, an uncommon age in those days to have children. Three of his siblings died in their infancy as a result of the plague.

The van Rijns lived in a modest house on the Weddesteeg in a neighbourhood called North Rapenburg. Their front door looked out toward windmills and the ancient town walls, beneath which flowed the Old Rhine. Harmen also owned half a windmill, part of an adjacent building and possibly other property.

Leiden, the birthplace of
Rembrandt.

While Rembrandt's parents were not rich, they were comfortably off. His father ground barley malt for beer, which would have put him in the lower ranks of the professional classes. He apparently injured his hand in an accident with a musket and applied to be discharged from the civic guard. Although his request was refused, he was excused from night duty. This allowed him to tend to his windmill in the evenings, when it operated best because of the breeze. Perhaps this was the real reason why he asked to be excused.

Leiden was famous for its cloth, and most of its 17,000 population worked in the textile industry. After undergoing a slump in the sixteenth century, business was booming again by the time of Rembrandt's birth, and many people from elsewhere in the Netherlands had arrived seeking work. Workers were poorly paid and, because of a shortage of houses, usually lived in small rooms. Those unable to pay rent were forced to live in huts outside the city walls.

THE REFORMATION

Northern Europe at this time had undergone profound change as a result of the Reformation. This broke the power and authority of the Roman Catholic Church and the pope, and split northern and central Europe between Catholic and Protestant, leaving a bloody trail in its wake and changing Europe's religious and political map for ever.

The Reformation started out as a theological movement for change directed against what were seen as Rome's unbiblical doctrines and corrupt practices. Discontent with some aspects of church practice and theology had, in fact, been bubbling away for as long as 200 years. Meister Eckhart, Thomas à Kempis, the Rotterdam scholar Desiderius Erasmus, and radical groups, such as the Brethren of the Common Life in the Netherlands, had all attempted in different ways to renew the church. While not all aspects of the church had become corrupt, few would argue that it was now urgently in need of reform.

The man who is credited with triggering the Reformation never intended to set in motion a chain of events that would have such profound

and far-reaching consequences. His name was Martin Luther, and he was a priest and professor of biblical studies at the University of Wittenberg in Germany. On 31 October 1517 he pinned what became known as his Ninety-Five Theses to the door of the Castle Church in Wittenberg. Luther challenged, among other things, abuses surrounding the Roman Catholic Church's doctrine of indulgences, which had become, some said, a 'holy trade'. Put simply, the doctrine of indulgences meant that a person could reduce the time they would have to spend expiating their sins in purgatory after death before being admitted to heaven through various penances. For example, pilgrims who venerated the relics at the Castle Church would avoid 1,902,202 years and 270 days of punishment. This kind of theology, Luther argued, had no basis in either the Bible or tradition.

Soon other theologians were springing up to challenge the authority of the Roman Catholic Church. One of the most influential among them was John Calvin, a Frenchman who had encountered the teachings of Luther in Paris. Calvin took up his ideas, writing and preaching about them and then developing them further. For Calvin, the supreme authority was the Bible, not the Pope and the bishops. He maintained that the Bible mentioned only two sacraments, baptism and communion, not seven as the Catholic Church taught. He also believed, parting company with Luther, that God had predestined some people for heaven and some for hell.

Calvin's ideas soon took root in the northern provinces of the Netherlands, and the first Protestant churches started to appear. By the time of Rembrandt's birth, Protestants governed the northern Netherlands, even though around half of the population was still Catholic, while the

*...in the seventeenth-century, Netherlands
theology was still a highly contentious
issue. By now it was clear that the
Reformation was not simply a matter of
Catholics and Protestants.'*

Flemish southern Netherlands, known as Flanders, was governed by Spain and remained loyal to Rome.

Rembrandt was born into a family with both Protestant and Catholic roots. His mother's side all remained Catholic after the Reformation. Harmen van Rijn, on the other hand, unlike his brothers and sisters, abandoned the old faith for the new ideas of John Calvin and the Dutch Reformed Church, which had become the official church of the land.

Gary Schwartz suggests in *Rembrandt: His Life, His Paintings* that many in Leiden would have considered Rembrandt's family politically suspect because of their Catholic connections. Religious ideas had an explosive power in the seventeenth century, and Rome was identified with Spanish rule and oppression. This may have been the case, but there seems to be no evidence that Rembrandt suffered from any kind of religious prejudice during the course of his career.

The major battles of the Reformation may well have been fought in the sixteenth century, but in the seventeenth-century, Netherlands theology was still a highly contentious issue. By now it was clear that the Reformation was not simply a matter of Catholics and Protestants. The floodgates had been opened and splits soon appeared among the reformers, who were unable to agree on what actually constituted the fundamental beliefs of Christianity. While the majority of Protestants were members of the Dutch Reformed Church, there were now also groups of Lutherans, Anabaptists, Mennonites and others. As a Dutch proverb runs, 'One Dutchman, a theologian; two Dutchmen, a church; three Dutchmen, a schism.'

And nowhere was religion more divisive and bitterly contested than in Leiden. The Calvinists soon became divided between conservatives and

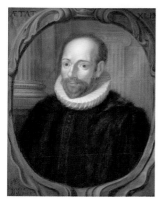

Jacobus Arminius,
the Dutch theologian,
who believed salvation
was dependent on the faith
and works of a Christian.

those who adopted a more liberal approach. These theological differences boiled over when an argument broke out between Jacobus Arminius and Franciscus Gomarus, two professors at the University of Leiden. Arminius believed that salvation was, to some extent, dependent on the faith and works of a Christian, a position seen as dangerously close to that held by the Roman Catholic Church. The conservative Gomarus, on the other hand, followed an interpretation of Calvin which asserted that the fate of each human being had been predestined by God from the beginning of time. Stricter Calvinists were also, for example, against Catholics being able to worship publicly and were opposed to the theatre and fairs.

In 1610 matters came to a head between the two camps when the supporters of Arminius (who had died the previous year) presented the States, or parliament, of Holland with a 'Remonstrance' calling for the amendment of Calvinist doctrine. Gomarus and his followers responded with a document known as the 'Counter-Remonstrance' expressing their support for the current profession of faith. So, having witnessed a split along Catholic-Protestant lines, the Netherlands was now split between the Remonstrants, the liberals, and the Counter-Remonstrants, the conservatives.

Following the Synod of Dort, an assembly of the Dutch Reformed Church held at Dordrecht in 1619, the Remonstrants were defeated and excommunicated from the church. Supporters of the Remonstrance were forbidden from teaching in universities and their public worship and meetings were banned. One of the Remonstrants' most influential figures, the statesman Jan van Oldenbarneveldt, was beheaded for treason.

It was against this turbulent and poisonous background that Rembrandt would have been taught about the Christian faith and the Bible.

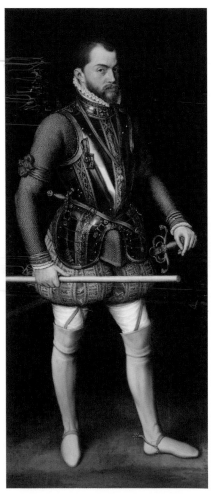

The Roman Catholic king of Spain,
Philip II.

Whether he had the kind of 'stern religious upbringing' that Kenneth Clark maintains in *An Introduction to Rembrandt* is open to question. A family that is rooted in the Christian faith is not necessarily one that is stern. And given that his father was Calvinist and his mother a Catholic, he would probably have been brought up in an atmosphere of tolerance and understanding rather than one of fundamentalism and bigotry.

What we can be fairly sure of, however, is that he grew up in a home where the Bible was read aloud by his parents and, most likely, prayers were said before meals. He would probably have attended worship with his family, at least some of the time.

SPANISH RULE

The Reformation spilled over into politics. When Rembrandt was born, the Netherlands was still engaged in a determined struggle to shake off

Spanish rule and fully establish itself as an independent state, in what was later to be called the Eighty Year War. From the late fifteenth century the seventeen provinces of the Netherlands, whose boundaries extended to eastern France and Germany and included most of what is today Belgium and Luxembourg, had been governed by the house of Habsburg. From 1556 they were under the rule of the staunch Catholic king of Spain, Philip II, nephew of the Habsburg Holy Roman emperor, Ferdinand I.

A movement of rebellion against King Philip's rule had been gathering momentum, fuelled by, among other things, his taxation policies and fear of the Inquisition. King Philip saw his role as upholding the decrees issued by the Council of Trent, which had been the Roman Catholic Church's response to the challenges from the Protestants, and putting down heretics. In 1567 he dispatched the Duke of Alba to be military governor of the Netherlands. Determined to prevent the kind of revolt that had occurred the year before, when churches were ransacked in protest against a bad harvest and the high price of bread, he set up the Council of Troubles, which resulted in thousands being arrested on charges of treason and heresy, many of whom were executed.

The rebels found a champion in the fight against Spain in William I of Orange. One of Europe's richest men, who had converted from Catholicism to Calvinism, he was the *stadholder* of Holland, Zeeland and Utrecht.

Rembrandt's home town of Leiden found itself at the centre of this dangerous mix of theology and politics. In 1574 the Spanish besieged Leiden for nearly four months. Cut off and lacking food, a third of the town's inhabitants are said to have died from hunger or disease. In 1576 Spanish troops rampaged through the streets of Antwerp, burning, killing,

and looting along the way. On 23 January 1579, representatives of the seven northern provinces of the Netherlands signed the Union of Utrecht, named after the city where they met, signalling independence from the rule of King Philip II of Spain and the birth of the United Provinces of the Netherlands.

Only days before, the southern states of the Netherlands had signed a treaty at Arras in which they pledged their loyalty to Spain. The once unified Netherlands was now split, with the south remaining loyal to Rome and the north allying itself with the Protestants.

Yet Spain still refused to cede power, and in 1584 an agent of King Philip II assassinated William of Orange. But King Philip's empire was rapidly crumbling and Spain was losing its control of the seas. Apart from his struggle in holding on to the Netherlands, he was having to deal with threats from two other powerful European nations, France and England, while in the East Islam was proving to be a difficult opponent.

An end to hostilities between Spain and the United Provinces came in 1609, three years after Rembrandt's birth, when, with the help of mediators from England and France, both sides signed a truce, agreeing to cease hostilities for twelve years. In effect, this meant that Spain was acknowledging the existence of the republic, although it was to be another forty years before this was done officially.

REMBRANDT'S EDUCATION

When he was six, Rembrandt was sent to school to learn to read and write. At the age of nine he transferred to the Latin School. But it appears he displayed little interest in his studies and that only painting and drawing were able fully to engage his young mind.

In 1620, he was enrolled at Leiden University in St Barbara's Cloister, a former convent situated beside the Rapsburg canal. The university had been established in 1575, shortly after the siege of Leiden, and was one of the first Protestant universities in Europe. Students were given a broad and classical education, studying theology, law, classics, medicine and engineering. Attendance at the university entitled students to a number of privileges, including the right to buy beer without excise taxes and exemption from service in the civic guard.

Rembrandt, however, only attended the university for a few months. Why this was, we don't know for sure. Jan Orlers says that the hope of Rembrandt's parents that he would grow up to serve the town in some way was soon dashed. 'But he [Rembrandt] hadn't the least urge or inclination in that direction, his natural bent being for painting and drawing only. His parents had no choice but to take him out of school and, in accordance with his wishes, apprentice him to a painter who would teach him the basics [of painting].'

Having finished with school and university, it was now that Rembrandt's real education, as a painter, was to begin.

Chapter 2
THE PUPIL

The route to becoming a painter in the Netherlands of the seventeenth century was to be apprenticed, usually in the early teens, to an established artist. A child's parents would pay the painter a fee for tuition, materials and board and lodging. The man who was given the task of teaching the teenage Rembrandt the basics of painting was Jacob Isaacsz van Swanenburgh, a Leiden artist who specialized in depicting architecture and hell.

Like many Dutch artists of the time, van Swanenburgh had journeyed south across the Alps to Italy to deepen his knowledge and understanding of art. Since the fourteenth century, Italy had been at the centre of an explosion of art in Europe that became known as the Renaissance, the like of which had never been witnessed before. Artists looked back to the classical world of ancient Greece and Rome for ideas and inspiration. In cities such as Florence, Rome and Venice, which vied with each other to attract the most outstanding artists to decorate their churches and public buildings, van Swanenburgh could see extraordinary paintings by great masters such as Michelangelo, Raphael, Titian, Leonardo and Caravaggio. He could gaze in awe at Michelangelo's *Creation* on the ceiling of the Sistine Chapel, contemplate Leonardo's *The Last Supper* or *Mona Lisa*, or marvel at Raphael's Madonnas.

Van Swanenburgh had worked in Naples, where he had married the daughter of a grocer, with whom he went on to have seven children. He was also a Catholic, and he had run into trouble with the Inquisition for selling a painting outside a church that depicted a group of witches.

His father had been a well-known painter and also a leading figure in Leiden, having served on the town council, as an alderman and

as *burgomaster* (mayor). Because of this, he is said to have had excellent connections to the court in The Hague. Whether this was one of the reasons why Rembrandt was apprenticed to him, as some art historians suggest, is unclear.

Rembrandt's biographers often dismiss van Swanenburgh as simply a mediocre painter. Lionello Puppi speaks for many when he says, 'We know from the few existing examples of van Swanenburgh's work that he had little to teach, even though he had followed the practice of travelling to Italy: he was an artist of little talent, whose technique was poor and uninspired.' While It's true that van Swanenburgh was not regarded as an outstanding artist, like Frans Hals in Haarlem, for example, he nevertheless must have passed on some very valuable lessons during the three years the young Rembrandt spent with him. After all, van Swanenburgh lived at a time when the Netherlands was producing an abundance of brilliant painters. Had he lived in another age, then perhaps he would have received more recognition. It's worth considering that his contribution to Rembrandt's becoming such a gifted artist may well be more significant than many have been prepared to admit.

LEARNING THE BASICS

We don't know whether Rembrandt lived with van Swanenburgh or remained at home with his parents, but we can be sure that, like any apprentice, he would have started at the bottom. Contemporary sources show that apprentices undertook the most menial jobs such as cleaning the studio, sharpening metal points and lacing canvases on what is known as a

stretcher. They also bound brushes, ground the various coloured pigments and mixed them with oil to make paints, primed canvases or panels with a ground layer and prepared copper plates for engraving or etching.

Van Swanenburgh's workshop is likely to have been a fairly Spartan room, containing little more than the artist's materials and equipment, a Bible and a few reference books.

As he progressed, Rembrandt would have learned how to draw, often copying van Swanenburgh's work, or sketching various objects. Eventually, he would have moved on to drawing animals and people. He would then have been taught how to use the palette and brushes. When van Swaneburgh decided he had reached the required level, he would have allowed Rembrandt to paint the less important parts of his paintings, for example costumes or landscape backgrounds. But the apprentice's name never usually appeared on the painting, only that of the master.

Painters worked on wood panels or cheaper canvas, sketching their designs first in chalk or pencil before adding a background colour. If they made mistakes, they would usually just paint over them. As Mariet Westermann points out, many artists prepared for their paintings by making preliminary drawings, including a sketch of the whole composition and detailed studies of figures, objects and body parts.

Apprenticeships usually lasted between two and four years, after which the apprentice would have to pass an examination, which often included producing a painting to demonstrate what he had learned. Having completed his apprenticeship, the next stage for a young artist was to set up a studio and take on his own pupils, while at the same time continuing to work for the master.

RELIGION AND ARTISTS

A consequence of the Reformation in the Protestant northern provinces of the Netherlands was that artists could no longer look to churches for commissions. While artists in Spain and Italy continued more or less as before, their counterparts in Protestant areas such as the Netherlands found that there was no longer a demand for pictures of saints in churches. The Protestant middle classes in northern Europe shared some of the characteristics of Puritans in England: they were devout, hard-working people who disliked pomp and they never accepted the flamboyant Baroque style of southern Europe. Altar panels had been a major source of income for many artists, but in the new religious climate these were seen to carry traces of popery and idolatry.

One artist in northern Europe whose work had not been restricted by the Reformation, and who was to be one of Rembrandt's greatest influences, was Peter Paul Rubens. He was born in 1577 in Germany, but his mother moved to Antwerp in the southern Netherlands after the death of his father. His father, who had fled Antwerp to escape religious persecution, had been a legal advisor to Anna of Saxony, the second wife of William I of Orange. He had been sent to prison for committing adultery with her.

Rubens studied under three masters in Antwerp and then went to Italy. In Rome he was commissioned to decorate the high altar of Santa Maria in Vallicella. Upon his return to Antwerp in 1609 he became court painter to Albert and Isabella, the regents of the Spanish-ruled southern Netherlands.

Whereas his predecessors in Flanders had mostly painted on a small scale, Rubens produced huge works, often to decorate churches and palaces.

He received commissions from the Jesuits in Antwerp, the Catholic rulers in Flanders, King Louis XIII of France and his mother Maria de' Medici, King Philip III of Spain and King Charles I of England, who conferred a knighthood on him.

But Rubens wasn't the only Flemish artist who was dazzling people with his paintings. His former pupil Anthony van Dyck was also making a name for himself in Antwerp and beyond, especially with portraits. He went on to become the court painter of Charles I of England.

LASTMAN

In 1624 the eighteen-year-old Rembrandt left Leiden and went to Amsterdam to study with Pieter Lastman. Lastman, who lived on the Sint Antoniesbreestraat, a street well known for its painters, art dealers and copying studios, was in a different league to van Swanenburgh. He was renowned for his biblical, mythological and historical paintings, all of which were known as 'history paintings'. Because they had to be so versatile, history painters were regarded as the elite artists in the Netherlands. They had to be able to paint everything: faces and figures, nudes, landscapes, architecture, animals and still lifes.

In 1603 Lastman had travelled to Italy, where he spent four years. He was influenced in particular by Caravaggio, who had become famous for his technique of *chiaroscuro*, contrasting light and darkness, and Adam Elsheimer, a German living in Rome who specialized in small-scale paintings. Lastman admired the Italian masters so much that he even signed his paintings Pietro, not Pieter.

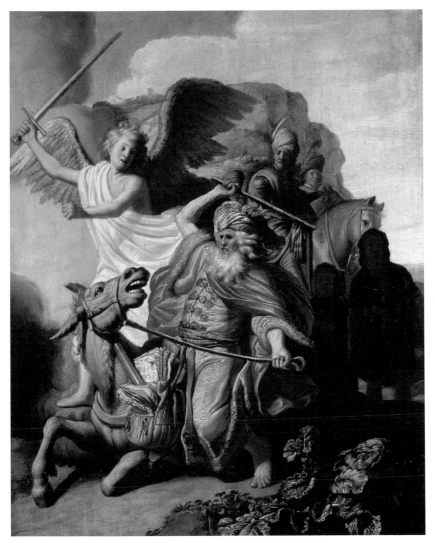

Lastman won some prestigious commissions, including designing a large window for the Zuiderkerk, the first Reformed church to be built in the Netherlands. He was one of a group of artists commissioned to provide scenes from the New Testament for the king of Denmark's chapel in Frederiksborg Castle.

Among the things Rembrandt would have learned from Lastman were the use of bright colours, and how to create facial expressions and use gestures to animate a picture. He also followed Lastman in finding the Bible

a gold-mine of fantastic and visual stories that offered an artist enormous scope to use all the skills he had acquired.

But it was not just Lastman's reputation as a painter that Rembrandt would have been aware of. Because of this reputation, Lastman also had the kind of connections Rembrandt needed if he was to become a successful artist himself. Rembrandt spent around six months in Amsterdam as a pupil of Lastman. It's possible that he may also have studied with Jacob Pynas for a short period of time, but this can't be proved.

LIEVENS

Rembrandt returned to Leiden in 1625. Having learned all he could from van Swanenburgh and Lastman, he was now ready and eager to launch his career. Like any young man setting out on his chosen path, he must have been brimming with excitement. He also must have dreamed of being a great artist and reaping the financial and other rewards that would come with success. At the same time, given the outstanding artists who had already established a reputation in the Netherlands, he might well have wondered in his quiet moments if he could compete with them, let alone surpass them.

He decided to team up with Jan Lievens, who was fifteen months younger than himself and who was something of a child prodigy. Lievens had also been born in Leiden. At the age of eight he was apprenticed to the painter Joris van Schooten before being sent to Amsterdam to study with Lastman. After two years he returned home to his father, and was soon astounding people with his artistic talent. At the age of fourteen he

did a portrait of his mother that, it is said, amazed all those who saw it.

Whether or not Rembrandt and Lievens shared a studio is unclear, but they certainly worked together, so closely that it was sometimes difficult to tell the difference between their paintings. They often painted the same subjects and copied each other. A note made in a 1632 inventory of works owned by Prince Frederik Hendrik of Orange records 'Simeon in the Temple, holding Christ in his arms, done by Rembrandt or Jan Lievens'.

REMBRANDT'S FIRST PAINTINGS

The Stoning of St Stephen, dated 1625, is thought to be Rembrandt's earliest painting. It is interesting that it is a scene depicting such violence, given that most of Rembrandt's work was marked by images of dignity, compassion and tranquillity. Was the young Rembrandt making a statement about how religion could be manipulated?

The story of Stephen, the first Christian martyr, comes from the Acts of the Apostles. Stephen was a Greek-speaking Jew who became a Christian. His preaching of the Christian message outraged the Jewish leaders, who had him arrested for blasphemy and brought before their council, the Sanhedrin, which ordered him to be taken outside the walls of Jerusalem and stoned to death. Rembrandt has included himself in the painting, peering out from behind the man who is about to smash a large rock on the head of the kneeling Stephen.

It is thought that Petrus Scriverius, a friend of van Swanenburgh, might have commissioned *The Stoning of St Stephen*. Scriverius was a humanist with a keen interest in poetry and the Dutch Middle Ages, and

he wrote several histories of Holland. He also penned Latin captions for van Swanenburgh's series of prints from drawings and paintings by four leading artists, including Rubens.

The influence of Lastman can be clearly seen in Rembrandt's early works. Like any artist, Rembrandt was feeling his way, trying to find his own style, while at the same time trying to imitate some of the paintings his teacher had done. *The Stoning of St Stephen* was a subject Lastman had painted; so too was *Balaam and the Ass*, Rembrandt's first Old Testament painting.

Rembrandt was to return to the Old Testament many times during his career, and he seemed particularly fascinated with the book of Tobit. Tobit was accepted as a biblical book up until the Reformation. But, along with a small number of other books, most Protestants rejected it because it was originally written in Greek and was never part of the Hebrew Bible. However, it was included in the first official Dutch Bible, published in 1637, following a decision made at the Synod of Dordrecht in 1618, although it was placed in a separate section known as the Apocrypha, at the end of the Old Testament.

The Stoning of Stephen, 1625,
was also a subject that Lastman
had painted.

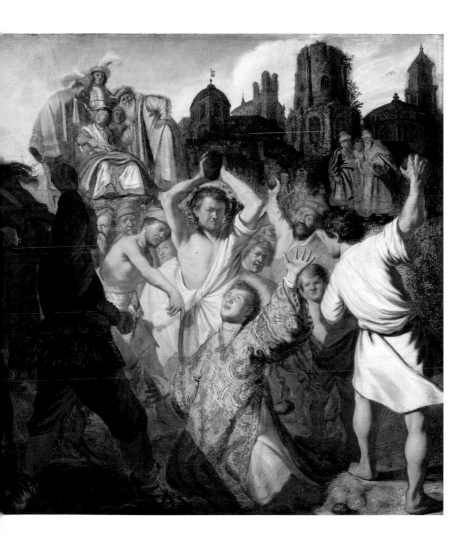

Anna Accused by Tobit of Stealing the Kid, 1626, features repentance as its theme.

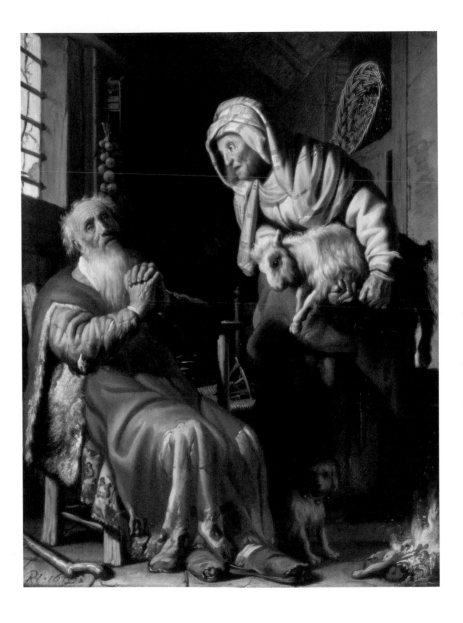

Rembrandt painted *Anna Accused by Tobit of Stealing the Kid*, most likely using an engraving by Jan van de Velde as his model, but adapting it to his own interpretation of the story. The blind Tobit and his wife Anna find themselves living in poverty. She brings him a goat one day, and he accuses her of having stolen it. When he realizes that he has accused her falsely, he breaks down and asks God to let him die.

This moment of repentance is what Rembrandt tries to capture. This is a theme that Rembrandt was to return to again in some of his most memorable biblical paintings. It's suggested that Rembrandt's mother may have been the model for Anna and his father the model for Tobit.

What is surprising about Rembrandt's early paintings is their size. They were tiny. For example, his painting of *Christ at Emmaus* is only 37.5 cm by 42.3 cm and *Anna Accused by Tobit of Stealing the Kid* is 30 cm by 39.5 cm. This makes them even more extraordinary.

Yet to be taken seriously by those whom he wanted to impress, he would have to prove that he possessed the ability to paint on the same kind of scale as Rubens and other great masters. But it wasn't until he was in his mid twenties that he felt confident enough to produce life-size paintings.

One of his early paintings which has been the subject of much debate is *The Music Lesson*. Art historians have failed to agree as to whether it is an allegory of moderation, or whether Rembrandt is depicting himself as the prodigal son. Gary Schwartz points out that the dignified manner in which the figures make their music points in one direction, and the piquant veiling of the young woman's breast in another.

LIGHT AND SHADOW

By contrasting two of Rembrandt's paintings from this period we can see how he was starting to experiment with the way he used light and shadow. From Lastman, Rembrandt had learned how to use *chiaroscuro*. This Italian word, meaning 'bright and dark', refers to the contrast of light and shadow, which gives a painting a three-dimensional feel. Lastman had developed this technique from studying one of its greatest exponents, Caravaggio, whose paintings adorned churches in Rome and were to be found in the collections of cardinals.

Caravaggio broke with the classical tradition and introduced realism into his paintings. It had been conventional to portray idealized images of both figures from the Bible and the great and the good. Caravaggio challenged this. Art historians such as Kenneth Clark see Caravaggio's *Calling of Matthew*, in the Church of St Luigi dei Francesi in Rome, painted around 1600, as a turning point in the history of art. But Caravaggio's career was not without controversy. When he painted *The Madonna of Loreto* in 1606 he included two pilgrims kneeling before the Virgin. There was nothing wrong with that, except that he depicted the man with dirty feet and the woman wearing a dirty cap. This was seen as scandalous by the church. And he ran into trouble with the church authorities again with his painting *The Death of the Virgin* because the Virgin Mary appeared genuinely dead.

Such was Caravaggio's influence in the Netherlands that a school of painters was named after him – the Utrecht Caravaggisti. Among those who imitated the Italian master were Gerrit van Honthorst and Hendrick

It had been conventional to portray idealized images of both figures from the Bible and the great and the good. Caravaggio challenged this.

Calling of Matthew by Caravaggio, c. 1600.

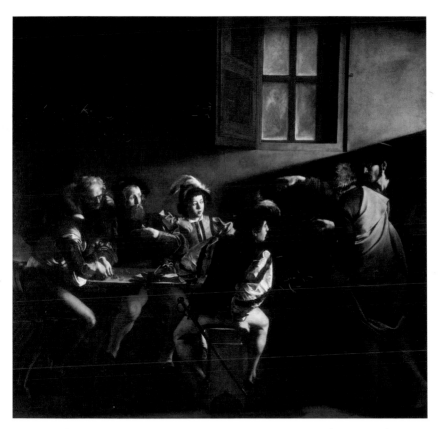

ter Brugghen. The influence of Caravaggio on van Honthorst can be seen in *Supper Party*, dated 1620, and on ter Brugghen in *Young Man Lighting a Pipe from a Candle*, dated 1623. But unlike van Honthorst, ter Brugghen or Lastman, Rembrandt had never seen Caravaggio's paintings in Italy.

THE PUPIL

In *The Money-Changer*, dated 1627, we can see how Rembrandt used the technique of light and shadow. Surrounded by piles of ledgers and documents, the money-changer sits alone in darkness, his face lit by a single candle. He can be viewed as a symbol of avarice. Rembrandt's inspiration for this atmospheric painting was Gerrit van Honthorst's *An Old Woman Inspecting a Coin*, thought to have been painted three years before.

Two years later, in his first painting of *Christ at Emmaus*, Rembrandt used light to replace the traditional halo that usually surrounded Jesus' head. The events in the story, from the Gospel of Luke, take place after the resurrection of Jesus. Two disciples are walking from Jerusalem to the village of Emmaus. A stranger joins them, and they are surprised when he appears not to know anything about the death of Jesus. The two disciples invite him to share a meal with them. When he breaks the bread, they are astonished to realize that he is, in fact, Jesus.

Rembrandt portrays this moment of revelation. One of the disciples and Christ are sitting at a table. Christ is in silhouette, sitting sideways. The second disciple is visible in the distance behind him. The disciple at the table is shocked by the discovery that the stranger is Christ, and knocks over a dish. Most of the painting is in darkness. It is Christ who is the source of the light.

Gary Schwartz goes as far as to say that *Christ at Emmaus* is the most daring painting that Rembrandt ever made, and as good as anything produced by Caravaggio, Rubens or van Honthorst. Yet he thinks the painting shows Rembrandt caught in a dilemma: how to please a patron with more of what he liked the first time while trying to improve on it.

Christus at Emmaus, 1629, illustrates Rembrandt's use of *chiaroscuro*.

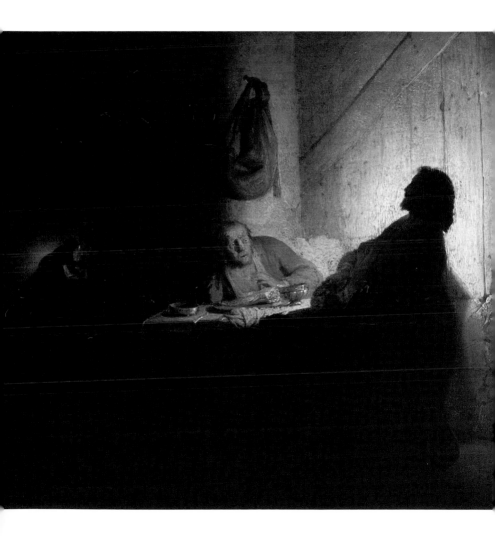

Commenting on Rembrandt's use of *chiaroscuro*, Robert Wallace writes, 'He used the intangible qualities of the visual world – light, air and shadow – to evoke the mysteries of the mind and spirit.'

HUYGENS

Like any artist, Rembrandt needed to become known in the right circles, if he was to obtain the prestigious commissions necessary to make his reputation and bring in the kind of income that would enable him to live well. And there was no better place to become known than The Hague, the seat of government in the Netherlands.

A man who was to play a key part in helping him achieve this was Constantijn Huygens. Huygens was one of those incredibly gifted people who seem to excel at everything they do. He was not only private secretary to Prince Frederik Hendrik of Orange, the *stadholder*, he was also a poet and musician, who had played the lute for the king of England. He was a linguist who had corresponded with the philosopher Descartes in three languages, and translated the poetry of John Donne from English into Dutch. On top of this, he had a good knowledge of physics, astronomy, theology, philosophy, architecture and painting. His achievements were not confined to the arts and learning. He once climbed the spire of Strasbourg Cathedral and was said to be able to mount a horse simply by leaping on its back. He was the kind of man who lit up a dinner party.

Huygens was passionate about art and always on the look-out for the latest new developments and new talent. He had not only studied the works of the masters in the Netherlands but also travelled to Italy and

A self-portrait, c. 1628.

England. And he was a pretty good amateur painter by all accounts. In Thomas Keyser's portrait of him, Huygens is shown sitting in front of a desk littered with various objects that reflect his very broad interests. Hanging on the wall behind him is a seascape by Porcellis, one of his favourite artists.

For Huygens, the greatest artist, not just in the Netherlands but also anywhere in Europe, was Rubens. But Rubens worked for the king of Spain and was also a diplomat, so there was no way that he would ever agree to paint for Prince Frederik Hendrik and the Dutch court. Huygens was looking out for a new Rubens.

Huygens paid a visit to Rembrandt and Lievens in the late 1620s and came away impressed by the two young artists, mentioning them in an essay written in 1629 or 1630. He thought Rembrandt the better painter because he penetrated to the heart of his subject. He was 'obsessed by the efforts to translate into paint what he sees in his mind's eye'.

As Gary Schwartz notes, Huygens was particularly impressed with Rembrandt's painting *Judas Returning the Thirty Pieces of Silver*, commenting that it was as good as anything he had seen in Italy: 'That single gesture of the desperate Judas – that single gesture, I say, of a raging, whining Judas groveling for mercy he no longer hopes for or dares to show the smallest sign of expecting, his frightful visage, his hair torn out of his head, his rent garment, his arms twisted, the hands clenched bloodlessly tight, fallen to his knees in a heedless outburst – that body, wholly contorted in pathetic despair.' He went on to say that no one could have achieved what Rembrandt – 'a smooth-faced boy' – did in the painting. More critically, however, he also remarked that Rembrandt and Lievens were arrogant and believed Italy had nothing to teach them.

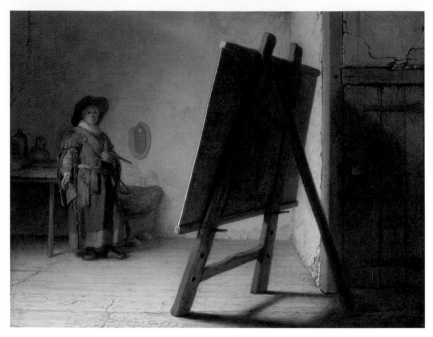

He felt they both needed to travel to Italy to learn more about art and see some of the works of masters such as Raphael and Michelangelo. But neither artist expressed any interest in this, telling him that they were too busy, and anyway it was possible to see examples of great Italian art in the Netherlands.

Huygens was both surprised and dismayed that two such talented young men showed such a lack of enthusiasm for visiting Italy. Quite simply, he thought them lazy. Although the impression we get from Huygens' essay is that Rembrandt and Lievens seemed to take his visit in their stride, they must have been flattered by his attention and praise.

Making a living as a painter was not easy. One way to generate extra income was to take on pupils. This Rembrandt did in 1628, and the first of his many students was the fourteen-year-old Gerrit Dou. Despite his age, Deu had already displayed great talent, painting stained-glass windows. He produced tiny, detailed scenes: when someone complimented him on his great skill in painting a broom the size of a fingernail, he replied that it wasn't finished; he still had three days' more work to do on it. He went on to become a very successful painter, and even turned down a position at the court of Charles II in England.

Isaac Jouderville was Rembrandt's other Leiden pupil. His guardians paid Rembrandt one hundred guilders a year, not including room and board, for two years to train him as an artist. This was above the normal rate for tuition fees.

In *A Young Painter in His Studio*, dated 1629, Rembrandt has given us a peek into his work. We see him standing alone, dressed in his work clothes and hat, holding a handful of brushes, staring at his easel. His studio is sparsely furnished, with none of the curiosities that he was later to spend so much time and money collecting. He seems to be deep in thought, possibly admiring his own work or wondering what to do next.

Huygens' visit underlined to what extent Rembrandt was regarded as one of the brightest up-and-coming artists in the republic. When Aernout van Buchell, a jurist from Utrecht, visited Leiden in 1628, he wrote of Rembrandt, 'The Leiden miller's son is greatly praised, but before his time.'

Rembrandt would have probably disagreed with this, feeling that his time had indeed come. His self-portraits from this period reveal a young man full of confidence, optimism and even a touch of arrogance. Having studied with van Swanenburgh and Lastman, learned how to paint detailed small pictures and use light and shadow, run a studio with Lievens and taken on his first pupils, he was ready to take his career to the next stage.

Chapter 3
AMSTERDAM

Amsterdam
was to become
Rembrandt's
home when he
arrived there in
1631 or 1632.

Rembrandt realized that if he really wanted to make his name, and his fortune, he must leave his home town of Leiden, something that Huygens might well have encouraged him to do. While it was a great centre of learning, Leiden was a backwater when it came to art. For an ambitious painter, there was only one place in the Netherlands to go: Amsterdam.

Amsterdam, just twenty miles from Leiden, was the centre of a thriving art market, with prints and paintings being sent there to be sold from Italy, England, France, Spain and across Europe. Everyone in the Netherlands who could afford it wanted to buy paintings. They were bought for homes, inns, hospitals, charities, orphanages and public buildings, and were sold in shops, by hawkers in the street and at fairs. Customers, or patrons, ordered pictures directly from painters, specifying subject, size and price.

Peter Mundy, an English traveller who visited Amsterdam in 1640, wrote,

> *As for the art off Painting and the affection off the people to Pictures, I thincke none other goe beyond them there having beeen in this Country Many excellent Men in that Facultty, some att present, as Rimbranyy, etts. All in general striving to adorne their houses, especially the outer or street roome, with costly peeces. Butchers and bakers not much inferior in their shoppes, which are Fairely sett Forth, yea many tymes blacksmiths, Cobblers etts, will have some picture or other by their Forge and in their stalle...'*

Art historians point out that there was no such thing as 'Dutch' art in

the seventeenth century. Instead, painters were considered to be part of a specific school of art, for example Amsterdam, Haarlem or Utrecht. And the Netherlands was awash with talent. Among the leading stars were Frans Hals, Jan van Goyen, Gerrit van Honthorst and Hendrick ter Brugghen.

Two things stand out about the explosion of art in the Netherlands of the seventeenth century. It was the first time that art had found a market for the private home. Before this, paintings had generally been commissioned by the church, the nobility and the royal courts. But the economic boom the Netherlands underwent in the seventeenth century meant that the middle classes had disposable income. Because there was a shortage of property and land to buy, they invested their money in banking, shipping, tulips and paintings.

And it was the first time art had achieved such prominence in a Protestant society. The great Italian art of the Renaissance had emerged from a Roman Catholic culture. Catholic churches relied heavily on visual images, as the ordinary Catholics in the pews were unable to read the Bible. But Protestants rejected statues, stained glass and altarpieces, believing that the images often smacked of superstition. Protestant churches were characterized by their simplicity and the absence of visual imagery.

When Rembrandt arrived in Amsterdam from Leiden, in either 1631 or 1632, he would have been aware of the stiff competition he was facing. However, he was far more accomplished and confident than when he had lived there while studying under Lastman seven years previously. And those six months in the city must have given him a good insight into the possibilities it offered to an artist with exceptional gifts such as his.

By contrast, Lievens had left the Netherlands to pursue his career in England. It was a move that worked out well for him. He became well known, painting the king and queen, the prince of Wales and other members of the court. After three years he moved to Antwerp, where his career continued to flourish and where he married the daughter of a sculptor and stonemason.

Amsterdam retained the system of tradesmen's guilds that had first been established in the Middle Ages. The guilds played an important part in business, setting working hours, minimum prices and quality standards. Rembrandt joined the guild of St Luke, the patron saint of artists, which controlled the production and sale of paintings, prints and sculpture.

Amsterdam was not just a great centre of art. It had become one of the most important cities in Europe and a magnet for those seeking to find work. New houses were springing up everywhere to cope with the demand. In 1600 its population had been 60,000. By the time Rembrandt arrived it had doubled, with an estimated 75 per cent of its inhabitants having been born elsewhere, among them Spanish and Portuguese Jews fleeing from the Inquisition. It was a bustling, cosmopolitan and exciting place. The philosopher Descartes wrote, 'Everyone is so engrossed in furthering his

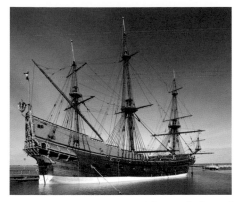

The Batavia Dutch East Indies Vessel, Leylstad. Sea trade contributed to Amsterdam's economic boom in the 17th century.

own interests that I could spend the whole of my life there without being noticed by a soul'.

Like Venice, Amsterdam had been built on a vast swamp, out of which had been created an intricate and very effective transport system of concentric canals, crossed by arched stone bridges, and along which horse-drawn boats carried people, goods and cattle.

THE DUTCH GOLDEN AGE

The Netherlands was enjoying a golden age. Christopher Brown writes, 'The emergence of the Republic of the United Provinces from the relative obscurity of a northerly dominion of Spain to become one of the leading powers of Northern Europe with its own empire in the Indies is the great success story of seventeenth-century European history.'

One of the chief reasons for Amsterdam's economic boom was the sea. The rival, Spanish-controlled port of Antwerp was blockaded for much of the seventeenth century by the Dutch, cutting off its foreign trade. Amsterdam became the major port in northern Europe, and its ship-owners became powerful and wealthy, as they controlled the freight traffic of Europe. One observer at the time wrote 'The vessels in this harbour are so numerous, as almost to hide the water in which they float, and the masts look at a distance like forests.'

As the Spanish empire declined, the Dutch empire began to dominate the seas. Its ships carried about half of Europe's trade. The prosperity of Amsterdam was largely due to the Dutch East India Company and the Dutch West India Company, which established trading posts or colonies

across the world, from Brazil and New York (which was originally called New Amsterdam before the English captured it and renamed it) to Ceylon, Java and the Moluccas. Their ships arrived in Amsterdam carrying gold, silver, spices, silks, ceramics and tobacco.

The city was dominated by the Exchange, where merchants and brokers from around the world traded goods, currency and stocks, and the Grain Exchange, the largest grain market in the world. Warehouses lined the streets around the Dam, the centre of its canal system, while in its square was a huge fish-market.

The merchants were the most important people in the city. Generally, they lived away from the smells and noise of the commercial centre, often in handsome houses, alongside canals such as the Herengracht, the Prinzengracht and the Keizersgracht.

In Leiden, Rembrandt had rubbed shoulders with people from other parts of Europe, but in Amsterdam he would see a much more cosmopolitan society. Its streets, alleys and taverns were crowded with sailors from Africa, the East and elsewhere, Jews from Portugal and Spain and immigrants from Poland, Greece and Italy.

VAN UYLENBURGH

Rembrandt moved in with the art dealer Hendrick van Uylenburgh, who was twenty years his senior, and his wife Maria in their house on the corner of the Sint Antoniesbreestraat and the Zwanenburgwal, near the Anthoniespoort, one of the main exits from the city. This corner of Amsterdam had become an artists' quarter. Among those who lived there

were Cornelis van der Voort, Nicolaes Eliasz, and Pieter Lastman, with whom Rembrandt had studied in 1625.

Van Uylenburgh had spent most of his youth in Poland, where his father was cabinet-maker to the king, but also some time working in Denmark. He had become one of the key movers and shakers in the Amsterdam art scene. He bought and sold paintings, imported prints from Italy and elsewhere in Europe and also ran an academy, where pupils learned to paint by copying paintings and etchings. The academy turned out all types of paintings: histories, mythological paintings and biblical scenes, anything that would sell. He was a sharp businessman, charging other artists a fee to make copies of paintings produced by the academy. To expand his business, he frequently took out loans from a number of investors.

Gary Schwartz takes a dim view of Rembrandt's involvement with van Uylenburgh, accusing him of using 'his accumulated fortune and dowry as the capital for a small, somewhat shady, art dealership'.

Rembrandt and van Uylenburgh had first met in Leiden. As Rembrandt had once lent him 1,000 guilders, the two men must have known each other reasonably well.

Some historians think Rembrandt may have taken Isaac Jouderville, one of his pupils, with him to Amsterdam, and also Jan Jorisz van Vliet, who helped him with his etchings and made reproductions of his paintings.

During the seventeenth century, most paintings were produced in studios. The studio, or *atelier*, functioned much like a factory. Often the master of the studio would lay out the painting and then his students would fill in large areas. Specialists existed who only painted heads, backgrounds, and so on. The master of the studio would often sign the painting even though it

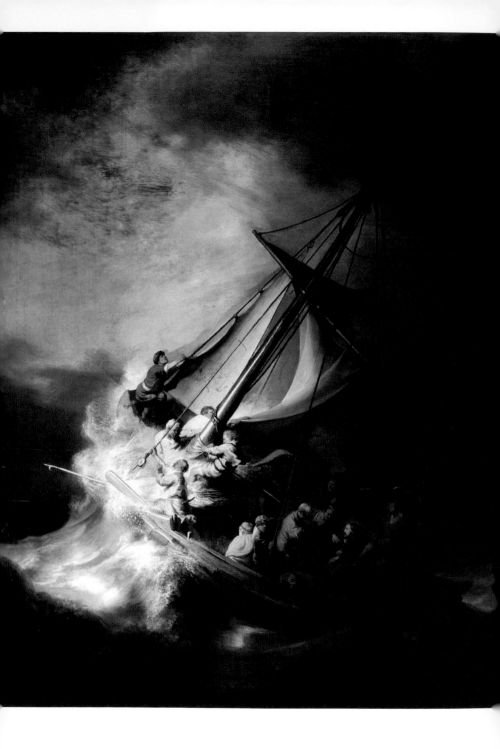

Christic in the Storm on the Sea of Galilee, 1633. It was Rembrandt's only maritime-themed painting.

might have been painted by several of his students. Painters sold directly from their workshops and through dealers, shops, annual fairs, public auctions and lotteries. They specialized in specific themes: landscapes, seascapes, history paintings, the Bible, classical subjects, animals, still lifes or domestic scenes.

Rembrandt was already in a different league from these young men. They were soon making copies of his paintings. When Lambert Jacobszoon, one of van Uylenburgh's pupils, died in 1637 six copies he had made of Rembrandt's paintings were found among his possessions.

Gary Schwartz says there is no evidence that Rembrandt received any income when his paintings were copied, and van Uylenburgh may have deprived him of income by allowing his creditors to hold his works by him and then copy them.

Around this time Rembrandt started to become known simply by his first name rather than his surname, as most of his contemporaries were. By choosing to be known by his first name he was following Rubens and Italian masters such as Michelangelo, Raphael and Titian. In other words, he was marking out the path he intended to travel.

FIRST COMMISSIONS

Rembrandt knew that if he was to make a decent living, he had to make inroads into the highly competitive art market. He needed a regular supply of commissions. But what should he specialize in? Should he continue with history paintings? Or should he try something different?

Landscapes and seascapes were very popular. The Dutch loved paintings of towns, villages, farms, windmills, canals, roads, ice skaters on

lakes, sand dunes, in fact anything to do with life in the Netherlands. The
demand for outdoor scenes might have had something to do with the fact
that the Netherlands had an urban culture, with around 75 per cent of its
population living in cities. By contrast, in nineteenth-century France 90
per cent of the population lived on farms.

Given the importance of shipping in the Netherlands, it's perhaps
not surprising that there was also a large demand for maritime scenes.
The States General, civic authorities and trading companies commissioned
paintings of the Dutch naval and commercial fleets. The best maritime
painters were handsomely paid for their work.

But Rembrandt was not interested in either landscapes or maritime
scenes. Neither the sea nor the countryside seem to have held any
fascination for him as subjects, although he did go on to produce a number
of drawings of Amsterdam and its surroundings. The only painting that
could be described as a maritime scene is *Christ in the Storm on the Sea of
Galilee*, dated 1633. But the focus of attention here is not the ship or the
sea but the two groups of disciples, one gathered around Jesus, the other
desperately struggling to gain control of the boat as waves threaten to
overpower it.

Rembrandt chose to specialize in portraiture. He was interested
in people. And the people who wanted their portraits painted were the
merchant class. In an age before photography, the only way to have your
image captured for posterity was to commission a portrait. Portraits were
fashionable in the Netherlands. It is claimed that Michiel van Miereveld, a
painter in Delft, produced over 10,000 paintings in his sixty-year career,
which works out at over three a week. If this is true, then he didn't get

bored with his profession – unlike Cornelis Ketel who, reputedly, resorted to painting with his tocs to amuse himself.

Two of the leading portrait painters in Amsterdam were Thomas de Keyser, who was not just a painter but also the city's stonemason and later its architect, and Nicolaes Eliasz. They had both built a reputation for providing the kind of portrait its citizens wanted.

The self-portraits Rembrandt had done during his time in Leiden had provided him with invaluable lessons in capturing expressions and the essence of a person. It was now time to test his abilities by painting the

well-to-do of Amsterdam. And it wasn't long before he received his first commissions.

Among the many people whose portraits he painted in the early 1630s were Marten Lootens, a partner in a trading company, and the fur trader Nicolaes Ruts. In both cases, Rembrandt simply presents his sitter as a successful and prosperous man (even though Ruts was on the verge of bankruptcy). The kind of peering into the soul of a person that was to become his trademark later on is absent. These paintings are commercial, just examples of Rembrandt trying to make a living. One suspects that he saw this kind of painting as his bread and butter, and that his heart lay elsewhere.

He also painted full-length pictures of Marten Soolmans and his wife Oopjen Coppit at this time, members of one of Amsterdam's most distinguished families. He showed both of them dressed in all their finery, which, presumably, is how they wanted to be seen.

His 1640 painting of Herman Doomer, an ebony worker who came from Germany, suggests that Rembrandt may well have bought frames from

him, and the two men may have been friends, especially as Doomer's son became one of Rembrandt's pupils.

A more interesting picture is *The Shipbuilder and His Wife*, a double portrait dated 1633. Because of the success of the Dutch fleet, shipbuilding had become one of the city's main industries. The work has echoes of Thomas de Keyser's 1627 portrait of Constantijn Huygens. Rembrandt portrays the shipbuilder Jan Rijksen, who worked for the Dutch East India Company, sitting at his desk, surrounded by the tools of his trade. He is receiving a message from his wife, who keeps one hand on the door. Similarly, de Keyser depicted Huygens, also surrounded by the tools of his trade, being given a message by a young man, possibly a clerk.

Rembrandt painted a number of religious figures, including Jan Wtenbogaert, a preacher and follower of Arminius who had once been tutor to Prince Frederik Hendrik at The Hague. He had also been a leading figure in the Arminian movement's battles with the Calvinists, and had been forced to leave the Netherlands in 1618. He had returned in 1626, much to the delight of his supporters. Another commission was from Dirck Janszoon Pesser, a follower of Wtenbogaert and a brewer in Rotterdam. But Rembrandt's portraits were not restricted to Protestants. He also painted Jan Hermansz Krul, a Catholic poet.

The Netherlands had strong trade links with the Ottoman and Persian empires. Rembrandt was fascinated by the exotic costumes he saw on the streets of Amsterdam, and he incorporated some of their features into his portraits.

Word soon spread about this very talented portrait painter from Leiden, and Rembrandt was inundated with commissions from merchants

1632's *The Anatomy Lesson of Dr Nicolaes Tulp* depicts the dissection of a criminal named Adriaensz.

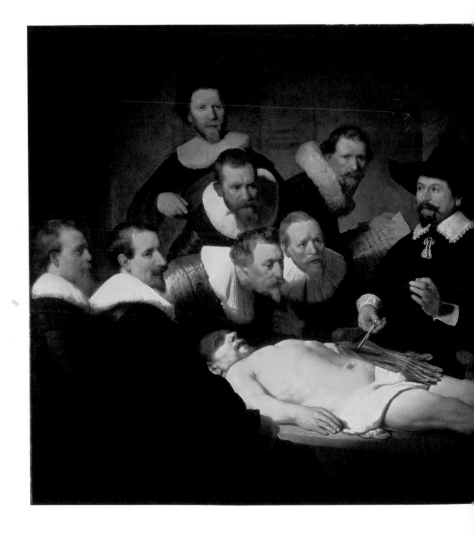

eager to be seen with one of his paintings on their wall. In his first year in Amsterdam he painted more commissions than in his entire career so far, and in his second year he exceeded that. It really is no exaggeration to say that he had burst upon the scene. In the words of Mariet Westermann, 'Rembrandt took Amsterdam's portraiture market by storm, with portraits that his contemporaries described as uncannily lifelike.'

Robert Wallace argues that Rembrandt departed from the classical tradition and took a radical approach to the human body. 'He was not then concerned with classical models; the anatomically improbable perfection of Michelangelo's figures may even have amused him. He saw the human body as it actually is, not as the classicists would have it, and in order to find his models it was not necessary to travel to Rome but merely to keep his eyes open as he walked down the street.'

DR TULP

If you really wanted to boost your reputation as a painter, especially of portraits, in Amsterdam, then the way to do it was to be commissioned to produce a group portrait of one of the city's guilds, militias or

other civic groups. Such paintings were very popular and were often hung on the walls of the houses where these groups met. And as each person who appeared in the painting would pay a fee for the privilege, they were also quite lucrative for an artist. They were great PR, likely to bring in further commissions.

In 1632 Rembrandt received his first major commission, the same year Lievens had sailed to England to work for the court. It came from the surgeons' guild. The guild had established a tradition of displaying paintings of anatomical demonstrations by the public anatomist. They had commissioned three previously, in 1603, 1619 and 1625.

Dissections of corpses were rare and solemn events, but also forms of public entertainmen, with the body usually being that of an executed criminal. In Rembrandt's painting, *The Anatomy Lesson of Dr Nicolaes Tulp*, which depicts a specific dissection, the body is that of Adriaensz, a man with a number of criminal convictions who was found guilty of stealing a coat and executed on 31 January 1632.

Dr Tulp was a physician, surgeon, author and head of the surgeons' guild. He was also the curator of both the Latin school and the university as well as a magistrate and member of the town council, later becoming burgomaster four times.

In *The Anatomy Lesson of Dr Nicolaes Tulp*, Rembrandt breaks with convention by using gestures and expressions to animate the macabre scene. Tulp is clearly the most important person in the painting. Rembrandt makes him stand out from the seven other men, who were not doctors but members of Amsterdam society, by giving him a wide black hat. It has been suggested that Rembrandt might have got the idea for the painting from Rubens' *The Tribute Money*.

In the opinion of Kenneth Clark, Rembrandt produced 'the painting of the year', and one that set him on the path to success. He was right. The painting helped Rembrandt to make his name and brought him dozens more portrait commissions.

THE ROYAL COURT

Scholars suggest that it was the well-connected Huygens who introduced Rembrandt to the royal court in The Hague, as noted earlier. He had been deeply impressed by Rembrandt when he had visited him in his studio a few years before. In 1632 Rembrandt was commissioned to paint a pair of small portraits, of Huygens' elder brother Maurits, secretary to the council of state in The Hague, and of Jacob de Gheyn III, an artist who became a canon at St Mary's in Utrecht. De Gheyn was a close friend of Huygens and had visited London with him in 1618 to see Lord Arundel's collection of antiquities.

Rembrandt also painted Joris de Caullery, an innkeeper and wine merchant from The Hague who served as a lieutenant in the civic guard. De Caullery had had a number of portraits painted of himself and his family by leading artists, including van Dyck and Lievens.

In the same year, Rembrandt enhanced his reputation at court when he was asked by Prince Frederik Hendrik to paint his wife, Amalia van Solms. This was a tremendous honour for such a young artist. Rembrandt knew the invitation meant that he was now part of an elite group of artists. The year before, it had been Gerrit van Honthorst who had painted the prince.

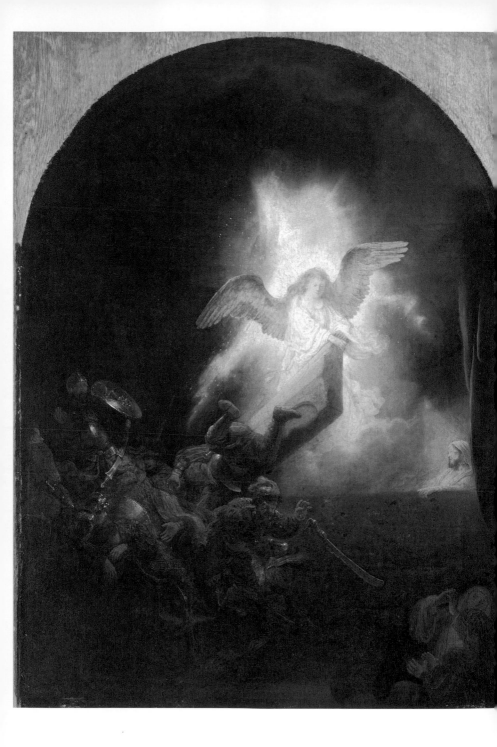

Rembrandt received several other commissions from the *stadholder*, who sometimes gave paintings as gifts to visiting dignitaries from overseas. For example, on one occasion he gave a self-portrait by Rembrandt and a portrait of a woman thought to be his mother to King Charles I of England via the king's emissary, Sir Robert Kerr.

THE PASSION SERIES

Rembrandt's painting of Dr Tulp had really put him on the map in Amsterdam. But he received an even more important commission when Prince Frederik Hendrik asked him to paint a series of paintings of the passion – the suffering and death of Christ.

Rembrandt must have been elated to receive such an honour, not to mention the money that it would bring in. In tackling the passion he knew that he was following in the footsteps of many great artists. So you would have expected Rembrandt to pull out all the stops for such a prestigious challenge, one that could boost his growing reputation as one of the rising stars. But, for some reason, he struggled to complete the commission. He had promised five paintings: *The Raising of the Cross*, *The Descent from the Cross*, *The Entombment*, *The Resurrection* and *The Ascension*.

By February 1636 he had completed just two of the paintings, *The Raising of the Cross* and *The Descent from the Cross*. What's particularly interesting about these is the debt they owe to Rubens. Rubens had painted both subjects twenty years earlier and won much acclaim for them. *The Raising of the Cross* was painted for St Walburga's Church in

Antwerp and *The Descent from the Cross* for Antwerp Cathedral. Given Rubens' fame at the time, Rembrandt would have been familiar with both works.

But Rembrandt fell behind in completing the other three paintings. The commission became the subject of correspondence between him and Huygens. Seven letters from Rembrandt to Huygens about the commission have survived. Unfortunately, we don't have Huygens' replies. Written between 1636 and 1639, the letters provide us with an invaluable insight not only into the commission itself but also into Rembrandt's character.

In a letter dated February 1636, Rembrandt told Huygens, 'I am diligently engaged in completing as quickly as possible the three Passion pictures which His Excellency himself commissioned me to do: an Entombment, and a Resurrection, and an Ascension of Christ.' He says that *The Ascension* has been completed and the other two are 'more than half done'.

After delivering *The Ascension* to Huygens soon after this letter, Rembrandt wrote to him again, this time raising the issue of his payment. He says, 'And as far as the price of the picture is concerned, I have certainly deserved 200 pounds for it, but I shall be satisfied with what His Excellency pays me.' He ends by suggesting that the best place to hang the painting is in the gallery, as there is a strong light there.

If, as Rembrandt had claimed, *The Entombment* and *The Resurrection* were more than half done, then why was it that three years later the prince was still waiting for them? We don't know the answer. It's baffling that he should have broken his promise to of all people the head of state.

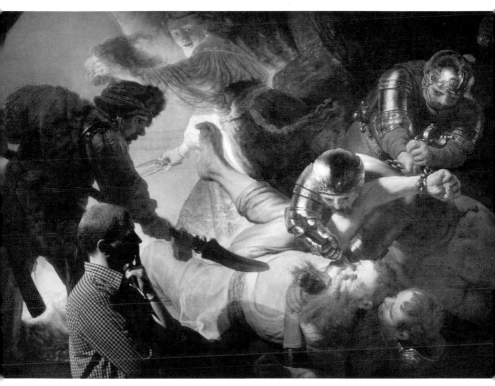

The Blinding of Samson, which Rembrandt sent to Huygens as a gift in 1639.

He found time to complete numerous other paintings during this period, including *The Risen Christ Appearing to Mary Magdalene*, *Belshazzar's Feast*, *Samson's Wedding* and several self-portraits.

In January 1639 Rembrandt wrote to Huygens, saying that *The Entombment* and *The Resurrection* had been completed, and praising himself for the 'great zeal and devotion which I exercised in executing well the two

pictures which His Highness commissioned me to make', and which had been finished through 'studious application'.

Rembrandt went on to say that the reason the paintings had taken so long to complete was that 'in these two pictures the greatest and most natural emotion has been expressed'. This comment provides a very revealing insight into his art. Rembrandt seems to be implying that he has broken with the classical tradition of portraying Christ and the other characters in biblical paintings in an idealized way. Instead he has tried to present them much more realistically. The figures in the paintings are portrayed as looking like the kind of people he would have met in the streets of Amsterdam.

Rembrandt ended his letter by saying that, in order to make recompense for taking so long to complete the paintings, he would send Huygens a 3 m by 2.5 m painting as a gift. Two weeks later, he sent him *The Blinding of Samson*, one of his most dramatic paintings. Kenneth Clark calls this a 'disturbing' painting, and suggests that it was therapeutic for Rembrandt as it helped him get out of his system his negative feelings about classical paintings.

At first glance, a painting such as this might seem an odd choice to give to such an illustrious and influential figure as Huygens. But, as Mariet Westermann says, 'Dutch historians presented their nation as the new people of Israel, small but selected by God for moral leadership. They therefore favored legends about Jewish heroes and heroines, such as Moses and Esther, who saved God's chosen people from destruction.'

In his covering letter, Rembrandt mentioned that Wtenbogaert, whom he described as 'the tax collector', had visited him and said that

he would be willing to make the payment due to Rembrandt. Although Rembrandt didn't seem to worry that he was so slow at completing the commission from the prince, when it came to his payment he wanted it immediately. He wrote, 'Therefore I would request you my lord that, whatever His Highness grants me for the two pieces, I may receive this money here as soon as possible, which would at the moment be particularly convenient to me.'

Money was his preoccupation once again when he delivered *The Entombment* and *The Resurrection* the following day. In the covering letter, he said that the paintings 'will be considered of such quality that His Highness will now even pay me not less than a thousand guilders each'.

It seems the prince was unimpressed with Rembrandt's request for more money. A couple of weeks later, Rembrandt wrote to Huygens, 'And as far as the earlier delivered pieces are concerned, not more than 600 carolus guilders have been paid for each. And if His Highness cannot in all decency be moved to a higher price, though they are obviously worth it, I shall be satisfied with 600 carolus guilders each, provided that I am also credited for my outlay on the two ebony frames and the crate, which is 44 guilders in all.' He asked to be paid as quickly as possible.

A few days later, the prince issued a payment order of 1,244 guilders to Thymen van Volbergen, his treasurer and paymaster general, but by April Rembrandt had still not been paid. Annoyed, he wrote to Huygens complaining about van Volbergen not paying him promptly and asking him to intervene to speed things up.

Rembrandt's failure to keep to his word seems to have damaged his reputation at court. Although he received two commissions from the court

in 1646, *The Adoration of the Shepherds* and *The Circumcision*, he received no other work. Rembrandt had made a costly mistake.

What's more, this episode surrounding the passion series put an end to Rembrandt's relationship with Huygens. If it was on his recommendation that the prince had commissioned Rembrandt, then he must have felt that his own reputation had suffered because of Rembrandt's inability to keep his part of the bargain and deliver the paintings on time. When Huygens was asked by the widowed Princess of Orange to make a list of artists who might decorate 'the house in the woods', one of the royal residences near The Hague, he didn't include Rembrandt, but did include some of his pupils.

Rembrandt must have been hugely disappointed to be out of favour with the court and to lose the patronage of Huygens. To rise to the top at such a young age and then come crashing down could have had catastrophic consequences for the confidence of some artists – but not Rembrandt.

PUPILS

Rembrandt's fall from grace at the court wasn't the kind of financial disaster that it might have been, as he had a regular income from teaching. By now, he had a large number of apprentices under his wing, each of whom paid around 100 guilders a year, as well as journeymen, who copied his paintings and collaborated with him. By the end of the decade he had so many pupils that it seems he had to rent a warehouse on the Bloemgracht to accommodate them all. He partitioned it in order to give each student his own studio. The pupils also made copies of Rembrandt's paintings, as was the custom in studios.

His pupils would at first have drawn plaster models and then moved on to life drawing. According to Houbraken, Rembrandt once caught one of his pupils peeping through a crack in the wall to get a glimpse of a naked female model. The student was also naked. When Rembrandt heard him say, 'Now we are exactly as Adam and Eve in Paradise, for we are also naked,' he called out, 'But because you are naked you must get out of paradise,' before entering the room, waving his stick, and forcing the naked student to flee down the stairs and out into the street. So the story goes anyway.

Govaert Flinck, who went on to become one of Rembrandt's most outstanding pupils, painted a portrait of him in 1639. Rembrandt looks serious, somewhat aloof and even self-satisfied. He is dressed smartly, wearing a cap and sporting an elegant moustache, every inch the image of the successful artist. Rembrandt must have been pleased with it.

Critics such as Christopher White detect a marked change in Rembrandt's portraits during the 1630s. 'The outward rendering of the appearance skilfully if superficially realized in *Marten Soolmans* was abandoned in favour of an inner portrayal which was increasingly to determine Rembrandt's treatment of the face, whether in a portrait or in an imaginary subject.'

He goes on to suggest that Rembrandt was able to do this because of his brilliant mastery of *chiaroscuro* and the application of paint. In painting a sitter's face, he suggests, the pattern of shadows was broken up so that, instead of the simple contrast between one half of the face in light and the other in shadow, light and shadow alternated in numerous small areas of varying intensity over the whole face.

The Abduction of Ganymede, 1635.

Gary Schwartz claims that between 1632 and 1635 Rembrandt painted one portrait a month in addition to other types of paintings, producing a finished painting every two weeks and an etching a month as well as numerous drawings. But between 1636 and 1638 he wasn't as productive, producing one painting every four weeks, none of them portraits.

When he wasn't doing commissioned portraits, Rembrandt painted self-portraits, biblical scenes, stories from mythology such as *The Abduction of Europa*, *Sophonisba Receiving the Poisoned Cup* and *The Abduction of Ganymede*, landscapes and pictures of people he simply found interesting, for example *An Old Jew*, *A Young Officer* and *A Man with a Turban*.

Rembrandt was beginning to establish his own style and use of colours by the early 1630s. His early works had followed the example of Lastman in using bright colours. But he was now using a softer palette, especially purple, bronze-green and muted yellows. He was brimming with confidence, and, despite his setback at the court, had become successful and comfortably off. But his mind was not just on his art. He was also beginning to think about marriage.

Chapter 4
FAMILY LIFE

The success Rembrandt had begun to achieve must have given him great satisfaction in his professional life. But he was still a single man. He wanted to get married and have a family. While he may not have been the most handsome man around, as his self-portraits reveal, given his reputation and his healthy income he would have been quite a catch for a woman in search of a husband.

The woman who entered Rembrandt's life was Saskia van Uylenburgh, who was six years younger than him and also Hendrick van Uylenburgh's first cousin. Born into a Calvinist family in Leeuwarden, in the province of Friesland, in 1612, she was the youngest of eight children. Her mother died when she was six and her father died six years later. At the age of sixteen she was made a ward of her sister Hiskia and her sister's husband, Gerrit van Loo, a lawyer and the town clerk of Het Bildt.

Saskia came from a higher social class than Rembrandt. Her father, Rombertus, had trained as a lawyer and had been the burgomaster of Leeuwarden and also the attorney general of the Dutch republic. He had witnessed the assassination of William I, Prince of Orange, while he was at dinner with him. What's more, he had been a member of a delegation sent to England to petition Elizabeth I to assume sovereignty of the Netherlands.

Rembrandt got engaged to Saskia on 5 June 1633 and they married on 22 June 1634 at the church of Sinta-Anna-Parochie in Het Bildt. His marriage to Saskia was good for his finances, as she is thought to have brought a substantial dowry with her. Whether Rembrandt's family was as unhappy about the marriage, because Saskia was from a

Rembrandt's etching of Saskia's cousin, Jan Cornelis Sylvius.

staunch Calvinist family, as some writers suggest, is open to question. One of her cousins, Jan Cornelis Sylvius, was a preacher who had served at the Groote Kerk in Amsterdam. Rembrandt did an etching of him, with his hands clasped over a Bible.

Shortly after his wedding Rembrandt gave Gerrit van Loo, his brother-in-law, power of attorney to collect Saskia's outstanding debts in Friesland. But not all Rembrandt's relations with Saskia's family were as good. In 1638 he sued two of her relatives, who he claimed were spreading rumours that Saskia had squandered her dowry. They must have believed that Rembrandt had only married Saskia for her money. Rembrandt lost the case.

In 1636 Rembrandt and Saskia moved out of van Uylenburgh's home and rented a house on the Nieuwe Doelenstraat which had a view of the River Amstel. The house was a few doors along from the Kolveniersdolen, the home of a militia company that was to play a major part in boosting Rembrandt's reputation as one of the Netherlands' most outstanding artists. In 1637 they moved to what was known as the sugar bakery, in Binnen Amstel.

A NEW MODEL

Apart from companionship, having a wife had another great benefit for Rembrandt. It meant that he now had a young female model readily available to him. Before his marriage, he seems not to have painted any portraits of young females. With a young wife at his side, he now made up for lost time.

1633 drawing of Saskia in a straw hat, completed shortly after becoming engaged to Rembrandt.

In fact, he had drawn, painted and etched Saskia before their marriage. In 1633 he did a drawing of her wearing a broad straw hat and holding a flower in her hand. Underneath he later wrote: 'This is drawn after my wife, when she was twenty-one years old, the third day after we were betrothed – 8 June 1633.'

In the same year he depicted her in two pictures as Flora, the Roman goddess of spring. In one she is adorned with a floral head-dress and holding a staff entwined with flowers; under her rich robes she appears to be pregnant. But she isn't, as she didn't give birth until December 1635. Rembrandt's use of flowers is unusual. He hardly ever painted them. In the other painting, Saskia looks almost regal.

In yet another portrait of Saskia from this period she is smiling and wearing a feathered hat, a transparent shadow across her forehead. Some art historians suggest that Saskia was also the model for Rembrandt's painting of Bellona, the goddess of war, and also for Bathsheba.

One of his most interesting and most discussed paintings of Saskia is his self-portrait with her, painted in 1635. The setting might be a tavern. He is laughing raucously, waving a glass of beer in the air, with his hand resting suggestively on the lower part of Saskia's back. She is sitting on his knee, but looking on with complete detachment. It

Saskia is depicted as Flora
in 1633.

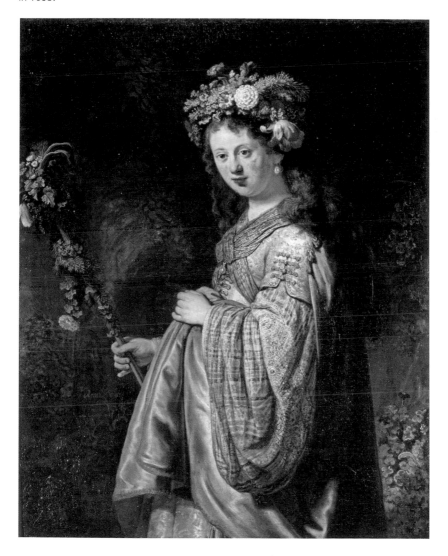

A self-portrait of
Rembrandt with Saskia,
1635.

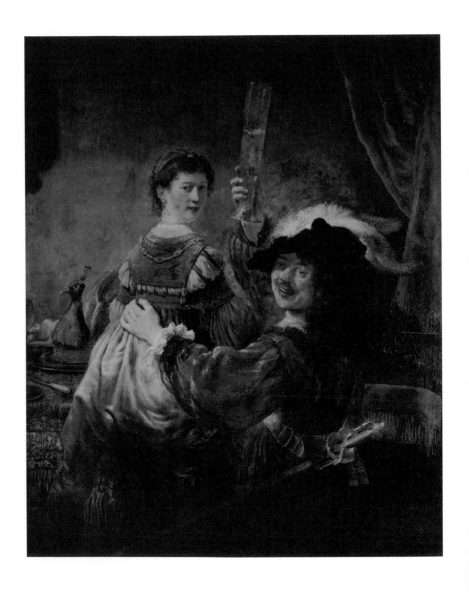

has been suggested that he is depicting himself as the prodigal son from Luke's Gospel. The theatrical costumes they are both wearing echo the way the Utrecht followers of Caravaggio often presented this subject. A Frans Hals painting of 1623 is thought to be a representation of the prodigal son in a tavern. Perhaps Rembrandt had this in mind. In fact, many painters turned out tavern scenes. They were very popular, as were brothel scenes.

Did Rembrandt feel deep down that all the success he was having, and all the money he was making, had taken him away from his spiritual and moral roots? After all, some of Saskia's relatives believed that the couple were living an extravagant lifestyle. Did he feel that he, like the man in the story Jesus told, was losing his way? Perhaps. Or he might just have been having a bit of fun after painting all those sombre portraits of merchants in their black and white.

Rembrandt's playfulness can also be seen in the portrait that one of his former pupils, Govaert Flinck, painted of him and Saskia in 1637, where they are depicted as a shepherd and shepherdess.

Though Rembrandt often used Saskia as a model, his model for *Danae*, his most erotic painting, dated 1636, remains a mystery. The face of the naked woman lying on the bed has none of Saskia's maternal qualities. Instead she is strikingly sensual and seductive. She appears to be inviting the man behind the curtain – possibly her lover – to join her. The painting shimmers with sexuality. This is Rembrandt as we haven't seen him before. Simon Schama talks about how 'the shadows on her body are calculated not as a poetic veil but as an erotic route map: the crease at her armpit; the little indentation at the base of her

throat; the underside of her fleshy arms; and the darkened, triangular valley of her sex.' These, he goes on, are 'meant to lead us across the golden threshold from vision to touch, from fantasy to possession'.

SUCCESS

By the mid 1630s, Rembrandt had established himself as one of the leading artists not just in Amsterdam but also in the Netherlands. It was said of him that when he was at work in his studio he was so absorbed in what he was doing that he would not even have given an audience to a king.

Rembrandt now wanted to live somewhere that reflected his success and reputation. The lucrative market for portraits he found among the merchants of Amsterdam may not have stretched his creative abilities, but it certainly enabled him to enjoy the kind of lifestyle he seems to have expected.

However, this is not to suggest that Rembrandt was driven solely by material gain. A German travelling salesman kept an autograph album with entries by rulers, university professors, government officials, artists and other distinguished people he encountered on his travels. Rembrandt's entry in 1634 consists of the head of a bearded man and with the inscription, 'A person with an upright disposition has more regard for honour than for possessions.'

Danae, a portrait of a mystery woman, dated 1636.

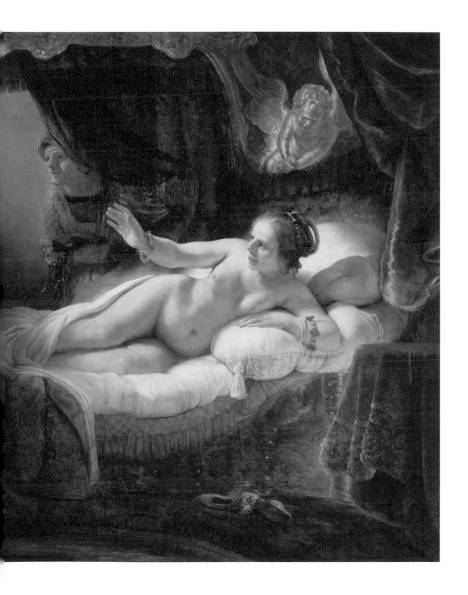

Rembrandt's
house, located at
Jodenbreestraat 4.

*A Young Man with
a Plumed Hat*
is an example
of Rembrandt's
fascination with
hats.

In 1639 Rembrandt bought an imposing three-storey house in the Breestraat, next to van Uylenburgh's house, for 13,000 guilders. He paid the owner, Christoffel Thijs, 1,200 guilders and agreed to pay the remainder in a series of instalments. This was a vast sum to pay for a house, and one, in retrospect, that Rembrandt was unable to afford. In contrast, the history painter Pieter Quast bought his house in The Hague for 1,900 guilders. But Rembrandt was thinking big. He had arrived and he wanted the merchants of Amsterdam to know it.

Rembrandt's purchase of the house explains his impatience to get paid for the series of passion paintings. Kenneth Clark says he bought such a grand house because he enjoyed showing off. Houbraken, on the other hand, presents a different image of Rembrandt, saying he 'lived simply, but content with some bread and cheese or a pickled herring as a whole meal'. The truth, as always, is probably somewhere in between. While Rembrandt was clearly no ascetic, equally he does not seem to have been someone for whom wealth was everything.

Rembrandt's success allowed him to indulge in collecting art and curiosities. He spent a lot of time attending auctions in Amsterdam. That he bought so many items could be seen as evidence of a materialist streak. But at the same time these hats, clothes and other things were the tools of his trade – the props and costumes that he used to dress his artistic subjects. He also bought paintings by other artists, including Rubens.

More than anything, Rembrandt loved dressing up. Had he not become a painter, then he might well have become an actor. Kenneth Clark says that in the 1630s Rembrandt was 'like a child finding a trunk of old

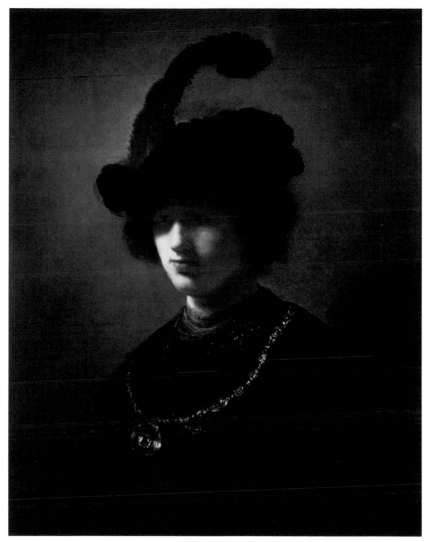

clothes in the attic and pulling out all the richest material it contains'.
In one self-portrait from this period he depicted himself in oriental dress,
wearing silk and velvet with a feathered turban.

Hats of every kind seemed to fascinate him. In the 1630s he painted
a number of portraits in which hats featured prominently, for example *Bust
of an Old Man in a Cap* (1630); *Bust of an Old Man in a Fur Cap* (1630); *An
Old Man in a Gorget and Black Cap* (1631); *A Young Man with a Plumed Hat*
(1631); and *A Man in a Gorget and Plumed Cap* (1631).

Self-portrait, dated 1640.

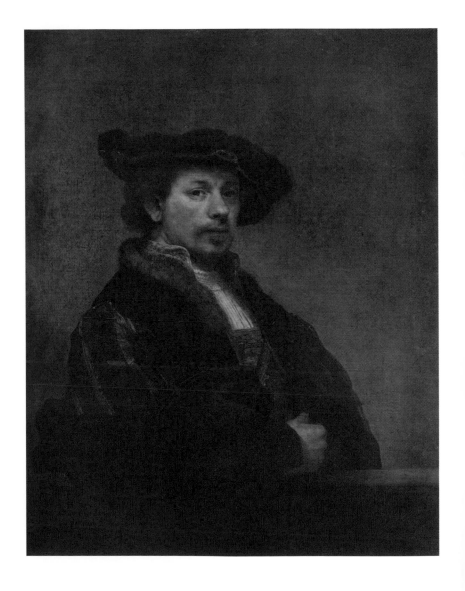

TRAGEDY

While Rembrandt and Saskia may have been very happy together, their early married years were marred by tragedy. Saskia gave birth to three children who each died within a few weeks of being born, a repeat of what had happened to Rembrandt's parents. In 1635 Saskia gave birth to Rombartus, who died when he was just two months old. Three years later, Cornelia was born, but she died within less than a month. A second daughter, also named Cornelia, was born in 1640, but lived for only a few weeks. In this period, Rembrandt's mother and Saskia's sister Titiana also died.

The answer as to why Rembrandt took so long to complete his series of passion paintings for Prince Frederik might lie here. The deaths of his first two children occurred at the same time as he was trying to complete this major commission. Rembrandt must have been distraught.

When Saskia became pregnant for the fourth time both she and Rembrandt must have expected the worst. In September 1641 Saskia gave birth to Titus, but this time, her child survived.

However, Saskia didn't live long enough to enjoy the motherhood she must have wanted so much. She had, in fact, been either pregnant or ill for much of her marriage. Rembrandt's drawings of her from this period show her in bed.

Saskia died on 14 June 1642, leaving behind Rembrandt and nine-month-old Titus. Rembrandt must have been devastated to lose his young wife. He made an etching of her just before she died and, the following year, he produced a portrait of her on a mahogany panel.

Just before her death Saskia had made her will. According to Dutch law, half of their estate belonged to Rembrandt. She was allowed to dispose of her half in any way she chose. She left it to Titus, stipulating that Rembrandt should receive interest from it until Titus married or came of age. But if Rembrandt were to remarry, then he would lose this interest. Her decision was to have repercussions for Rembrandt long after her death.

Chapter 5
PORTRAITS

One of the leading painters of group portraits in the Netherlands was Frans Hals. Among his well-known works was *The Assembly of Officers and Subalterns of the Civic Guards of St Hadrian* at Haarlem, painted in 1633. Paintings of officers in the civil militias were common, and Hals had served in the civic guard in Haarlem himself. The militias had been originally established to guard the gates of their cities and help keep law and order. But by the middle of the seventeenth century their role had become more symbolic and ceremonial.

THE NIGHT WATCH

Saskia's death in 1642 coincided with the completion of Rembrandt's most ambitious single work to date, which was also a militia group portrait. *The Night Watch* took him about a year and a half to paint and was to become not just the largest painting he had ever done, but one of his most famous.

A few doors along from Rembrandt's house in the Breestraat was the home of the Kloveniersdolen, one of the city's twenty militias. It was under the command of Captain Frans Banning Cocq, a leading civic official. When the group decided they wanted a painting to mark the decoration of the new hall in their headquarters, they commissioned Rembrandt. As we saw, he had shown in his painting *The Anatomy Lesson of Dr Nicolaes Tulp* his great talent for group portraits.

In the words of Simon Schama, 'Rembrandt was aware he was playing for high stakes. Here was the moment where he could cancel out all the frustrations and confusions of the Passion series, where he could take his leave of the anxiety of influence: where he could do more, be more,

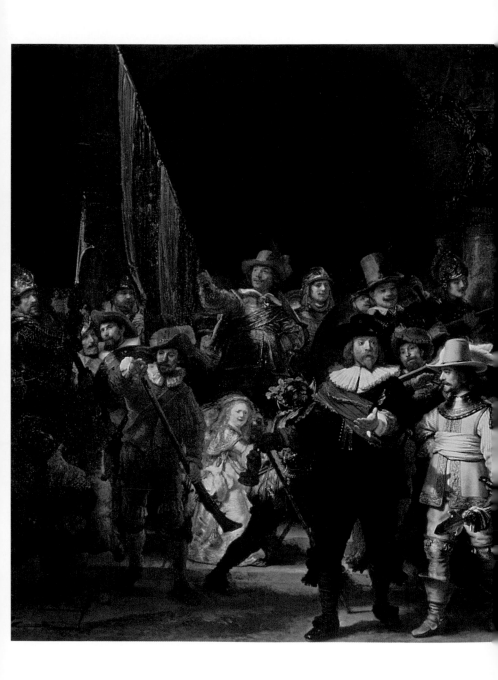

The Night Watch of 1642. It was formerly known as *The Militia Company of Captain Frans Banning Cocq,* and has caused controversy.

than Rubens. A triumph would make him. A disaster would break him.'

Rembrandt produced what later became known as *The Night Watch,* measuring 3.6 m by 4.2 m. It was originally called *The Militia Company of Captain Frans Banning Cocq,* but was named *The Night Watch* in the eighteenth century because it had been darkened by varnish. What makes the painting different from other group portraits of the time is that Rembrandt did not portray the members of the militia in the traditional, rather formal pose, but animated each of them. In other words, they are shown in action, marching behind Banning Cocq, who is gesturing with one hand. Pikes are raised in the air, muskets primed for action and a drummer beats his drum. The painting bristles with activity. Instead of wearing the black and white clothes that were so common at the time, the figures are all dressed in different colours. Although Banning Cocq wears black and white, he has a red sash across his chest. Rembrandt also added children and dogs to the scene, something that hadn't been done before. The arch in the background represents the city

gate that the militia was supposed to guard. It has been suggested that while the eighteen militiamen included in the painting each paid a fee, the sixteen other figures didn't.

According to some Rembrandt experts, the men with muskets are wearing clothes from the sixteenth century rather than the seventeenth, while the helmets are not the type worn in Amsterdam at the time. This could have been because the men kept antique weapons and costumes for ceremonial occasions, or because Rembrandt wanted to indulge his passion for dressing his subjects up to add a bit of fun to the painting.

In *The Night Watch* Rembrandt reached the peak of his talents. He brought together his brilliance as a portrait painter and as a history painter. In fact, given its size and extraordinary detail, it could be argued that *The Night Watch* is not one painting but several joined together. The composition, what Simon Schama calls 'the heavy engineering of Rembrandt's pictorial machine', works to combine portrait, history painting and allegory in a single work.

In around 1715 the painting was moved from the militia headquarters to Amsterdam Town Hall, and it was cut to make it fit on the wall.

Despite the technical brilliance of *The Night Watch*, it has been a controversial painting in Rembrandt's career. Some historians argue that it is overrated; others that it marked the beginning of a downward spiral in Rembrandt's fortunes. There is a story that the members of the company weren't happy with the painting and refused to pay their 100 guilder fees for inclusion because they didn't think they were prominent enough. But Seymour Slive, a former Professor of Fine Arts at Harvard University, claims there is no evidence to support the view that the patrons of *The Night Watch*

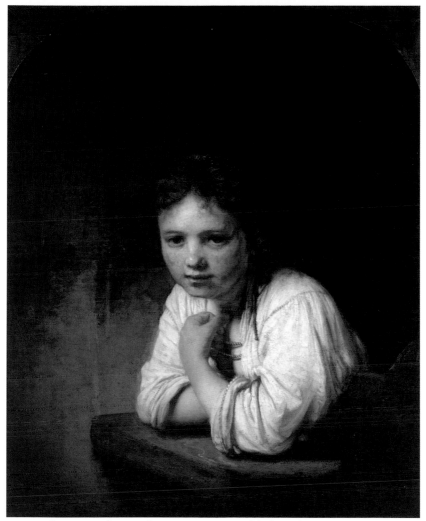

were unhappy with it, or that it was responsible for a decline in Rembrandt's career. 'On the contrary, contemporary documents prove that Rembrandt was handsomely paid for the masterpiece. He received about 1,600 guilders for it, or about 100 guilders from each man figured in the composition.'

While it's true that Rembrandt's output seemed to slacken off in the 1640s, the evidence that *The Night Watch* triggered a decline in Rembrandt's career is shaky. He may not have been as productive as he was in the 1630s, but he still turned out paintings such as *Young Girl at a Window*, *Christ and the Woman Taken in Adultery*, *Susanna and the Two Elders* and

A Winter Landscape, along with etchings including *The Three Trees* and *Jan Six*. Moreover, Captain Cocq had a watercolour copy made of *The Night Watch* for his private collection.

However, Slive adds that there was indeed a change in the appreciation of Rembrandt's work, but it had nothing to do with *The Night Watch*. The change occurred when Rembrandt stopped making 'sensational pictures which explode with Baroque excitement' and instead 'began to concentrate upon finding ways to make colour, *chiaroscuro*, and atmospheric effects, instead of emphatic gestures and expressions, establish the mood of a picture or the condition of a soul'. He thinks that after the death of Saskia Rembrandt became more concerned with the inner life of his subjects.

PORTRAYING THE INDIVIDUAL

The Reformation had not only split the Roman Catholic Church and given birth to new churches but had also called into question some of the traditional beliefs about the world that the Catholic Church taught. Lutheranism stressed the personal faith of the believer as the path to salvation; Calvinism emphasized the believer's individual election by God.

A Winter Landscape, 1664.

Both tended to sideline the role of the church as an institution. This also helped to encourage ways of looking at the world and the self that were increasingly independent of theology. Thinkers such as Copernicus and Galileo – rejecting the belief that the earth was the centre of the universe – had started to favour experimental science over theology.

At the same time a great expansion of activity and opportunity in trade and commerce helped to underline the possibilities for the individual in the world. Under these various influences a growing sense of the importance of the self began to emerge. The French philosopher René Descartes had famously proclaimed, 'I think, therefore I am.'

It could be argued that this emerging sense of self contributed to the popularity of portraits in the seventeenth-century Netherlands. One of the reasons people commissioned portraits was to make loved ones seem present while physically absent and to preserve their memory after death. Because portraits were usually on public display, they were also a way for the middle classes to present themselves as they wanted others to see them. This meant, for example, that they should appear prosperous, dignified and virtuous.

In the sixteenth century only members of the nobility were seen to be worthy of a portrait. The majority of portraits from that period were of monarchs, aristocrats and other powerful figures. In the seventeenth century this was no longer the case. A much broader range of people now featured in portraits.

Twin portraits of husbands and wives – 'pendants' – were very popular. These might be hung on either side of a chimneypiece, facing one another, the woman on the right, the man on the left. Another popular type

was the family portrait. These cost more, as portraits were priced according to the number of people in a painting.

Most of the portraits Rembrandt did in the 1630s and 1640s, of merchants dressed in black and white, the men usually sporting beards, appear little different from those painted by other Dutch artists of the time.

It has been said that in his approach to portraits Rembrandt rarely used the environment to tell us about the person. Instead he preferred to use the pose and expression to do this; the backgrounds to Rembrandt's portraits were usually plain and dark to emphasize the features of the subject. But this is not strictly true. We can learn a lot about the sitters from the clothes they wear. While the sober black suits and dresses and the white ruffs or lace trims were the typical fashion of the middle classes in the seventeenth-century Netherlands, they still reveal much about the person. The type of black fabric used was often very expensive. Some clothing was made of silk. And the suits and dresses might be elaborately embroidered. This, and the width of the lace, would indicate that a person was wealthy. So would white collars or cuffs, because white clothes were difficult to keep clean, and suggested that the wearer could afford to hire someone to wash and starch them.

Betsy Wieseman, curator of Dutch paintings at the National Gallery in London, told me that while Rembrandt's portraits are very typical of his period, what makes them different is how they are painted. 'If you look at lace or a gold chain in a portrait you see that he doesn't paint everything in a minutely and meticulous photographic way. For a creative painter churning out portraits of anybody who walked in the door it probably got

An engraved portrait of
Jan Six, 1647.

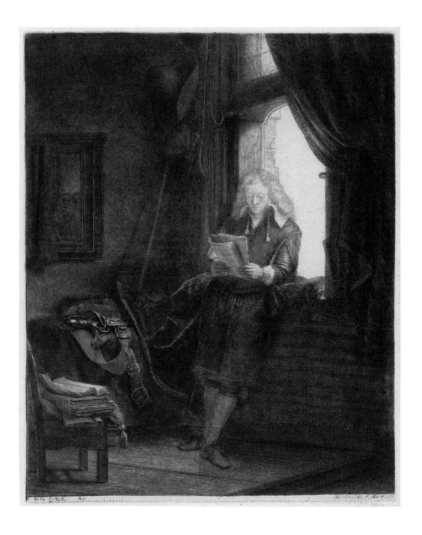

a little boring. He used different techniques to paint lace. They changed according to the style of lace that was fashionable.'

In the 1630s Rembrandt had stormed the Amsterdam portrait market, producing paintings of many of the city's leading merchants. As Gary Schwartz says, 'Once Rembrandt got his chance, it became clear that there was a demon of a portraitist in him.'

But by the 1640s Rembrandt had moved away from painting the merchants who had once provided him with a steady income. Like Wieseman, Kenneth Clark argues that the commissions he accepted from the 'prudent, cheese-faced merchants of Amsterdam', in their sober black clothes with stiff white linen, had begun to bore him. They failed to reflect the richness of life.

This does indeed seem to be the case. Rembrandt could never be happy churning out this kind of portrait, like a hack. He was constantly seeking new challenges and new ways of treating subjects. He was too restless to settle for simply earning a decent living by supplying the demands of the Amsterdam art market. He was possessed by something much deeper. Painting for him was not just about production. It was a way of expressing truths about people, the world they lived in and their ultimate destiny. The figure of Christ had always fascinated him, and he painted a series of heads of Christ between 1645 and 1655.

But in the early 1650s Rembrandt returned to painting wealthy Amsterdammers. The last time he had done this was when he painted *The Night Watch* in 1642. Among those he painted were Floris Soop, a member of the civic guard, and Nicolaes Bruyningh, who had inherited a large fortune from his grandfather and then subsequently lost it.

Rembrandt was fascinated with elderly people. *Portrait of an Old Woman* is just one of his paintings depicting this theme.

One of Rembrandt's most famous portraits of the 1650s is that of Jan Six. Six was twelve years younger than Rembrandt and came from a family of Huguenot (French Calvinist) refugees. He was a poet and, like Rembrandt, a collector of paintings and curiosities. Rembrandt had known Six for some years, and had etched his portrait in 1647. He also provided an etching for Six's epic poem *Medea*, which was published the following year. Rembrandt had visited Six's house in the country, and produced an etching known as *Six's Bridge*.

In 1654 Rembrandt painted a portrait of Six. In it, Six is pulling on a glove, with his bright red cloak draped over his shoulder. He looks every inch an intelligent, prosperous, important and reflective man about town. The portrait is certainly flattering. But the friendship between the two men seems to have ended after this. When Six married the daughter of Dr Tulp the following year, he gave the commission to paint her not to Rembrandt but to two of Rembrandt's former pupils, Bol and Flinck.

Throughout his career Rembrandt never lost his fascination with old people. In his early years in Leiden he had produced works such as *Two Old Men Disputing*, *An Old Man Sleeping Beside a Fire* and *An Old Woman*. In the 1650s he produced another series of paintings exploring old age. Among them were *An Old Man in an Armchair*, *An Old Man with a Beret* and *An Old Woman with a Hood*.

Maybe Rembrandt loved the beauty and complexity of old age, of how people accumulate years of experience. He also saw far beyond the worn and wrinkled face before him to something invisible but more important than physical beauty. It has been suggested that with his penetrating gaze he could see deep into the soul of his subjects.

*It has been suggested that
with his penetrating gaze
he could see deep into the
soul of his subjects.*

SELF-PORTRAITS

Rembrandt's fame as an artist meant that many wealthy Amsterdam merchants wanted to buy paintings of him. He was a celebrity. If they managed to buy one of his self-portraits they got both him and an example of his work.

The kind of wonderful detail that Rembrandt was able to produce in *The Night Watch* was the result of painting portraits for around fifteen years. And he had begun to learn how to paint portraits by making numerous pictures of himself, from those first days in his studio in Leiden. It would be wrong to see this as evidence of excessive vanity. The reason he painted himself so often was a practical one: he needed a model. And there was no better model than himself. He was always available, and didn't need to be paid.

During his career, Rembrandt painted around fifty self-portraits. They capture his changing appearance, from the sometimes cheeky youth of the 1620s to the much wiser and portly man of the 1660s. And they also reveal a variety of expressions: rebellious, happy, troubled, content, resigned, defiant, and so on. Some historians have traditionally seen these self-portraits as a kind of spiritual autobiography.

Rembrandt's self-portraits had different purposes. Some of the earliest ones served as nothing more than practice; others were meant as probing self-analyses; and others were simply self-advertisements or calling-cards to drum up business.

Some notice a change in Rembrandt's style in self-portraits after 1631. Charles Mee thinks he abandoned a casual look and began to adopt

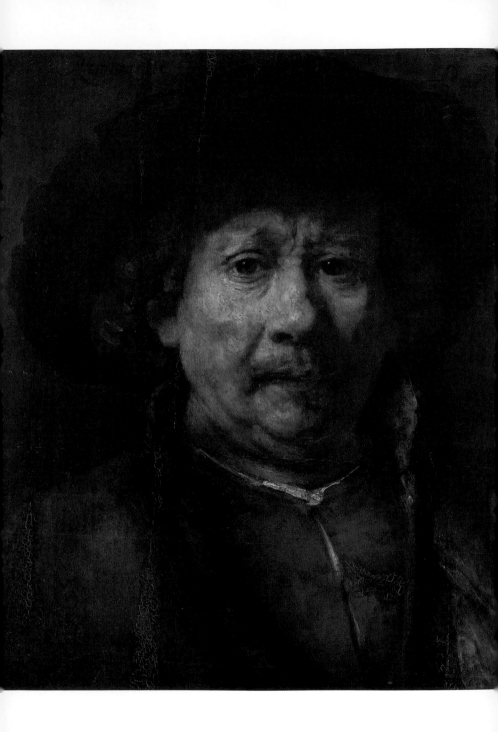

A self-portrait from 1655.

The fact that there is so little
known about Rembrandt's life
inevitably focuses attention on
his self-portraits to provide clues
as to the kind of man he was.

the fashion of the wealthy middle classes of Amsterdam. 'He wears a dashing, wide-brimmed felt hat that is decorated with a gold chain, and beneath his sparkling white collar he has on a fine black quilted doublet with golden buttons down the front. He is ready to go to the city.' Walter Liedtke agrees, saying that, in his self-portraits of the 1630s and 1640s, Rembrandt paints himself as a 'Renaissance gentleman'.

The fact that there is so little known about Rembrandt's life inevitably focuses attention on his self-portraits to provide clues as to the kind of man he was. Kenneth Clark sees various aspects of Rembrandt's personality in them: the rebel, the fashionable and intelligent man about town and the thinker who pondered questions about God. He says that, with the possible exception of van Gogh, Rembrandt is the only artist who has made the self-portrait a major means of artistic expression and who has turned self-portraiture into an autobiography.

Mariet Westermann observes that very few painters have portrayed themselves more frequently, and in more varied guises, than Rembrandt. 'From his apprentice days, he sketched, etched and painted his own face and body, leaving almost two self-portraits per year of his career. The function of these works has been the subject of heated debate.' She adds, however, that no self-portraits were recorded in the inventory of his possessions drawn up in 1656 and few were owned by international collectors.

From the number of self-portraits he did, and the fact that he sometimes included himself in his history paintings, we can conclude that Rembrandt was clearly not a shy or modest person. Gary Schwartz says that the quality of Rembrandt's self-portraits is often better than that of his portraits and studies of others. This was, he suggests, because he

97

spent more time on them and knew his own features better than anyone else's.

In 1658, at a time when his personal finances were in crisis, Rembrandt painted another self-portrait. Measuring 102 cm wide and 131 cm high, it was the largest self-portrait he had painted. Despite his financial disaster, Rembrandt refused to see himself as a broken man. He painted himself sitting regally in a chair, holding a cane. His expression is one of dignity and self-confidence. It's almost as if he is saying, 'I may have lost my house and my possessions, but I am much more than all of that. Just watch me and you will see that I am still a great artist.'

Chapter 6
THE BIBLE

I f there was one thing that set Rembrandt apart from many other painters of his time in the Netherlands, it was his preoccupation with the Bible. It's significant that his first ever painting was a biblical one, *The Stoning of St Stephen*. Of course, he wasn't the only artist in the Netherlands painting biblical scenes, but he painted far more than anyone else. And no other artist seemed to possess his feel for the stories and be able to uncover the insights they provided into the workings of God.

As a child Rembrandt would have had some of the dramatic Bible stories read to him. It has been suggested that the elderly woman reading the Bible in Rembrandt's 1631 painting *An Old Woman Reading* is his mother. Others have identified her as the prophetess Anna, who greets the infant Christ in Luke's Gospel. What we can say is that Rembrandt seems to have used as a model the same woman who features in the Old Testament scene *Anna Accused by Tobit of Stealing the Kid*.

Rembrandt's imagination must have been stirred by the exploits of Old Testament characters such as Abraham, Moses, Samson and David. In the New Testament, he must have found profound meaning in the story of Jesus' birth, ministry, death and resurrection. And in Peter and Paul he would have seen two men struggling with their own doubts and weaknesses as they went out to proclaim Jesus as God's saviour to the world.

Religion in seventeenth-century Europe was finding itself challenged by a new and growing philosophy of humanism, which didn't rely upon the Christian narrative to make sense of the world. And this move away from the Bible, as well as the Protestant rejection of the use of images, was reflected in the works of many Dutch artists, who turned to subjects such as domestic scenes and nature to express

their ideas about the place and purpose of human beings in the world. Yet despite the new scientific and philosophical ideas that were taking root in the Netherlands, the Bible still provided many people with a common account that explained the origin and destiny of humankind. Rembrandt's fascination with some of the great biblical stories remained with him throughout his entire career.

The Bible, of course, had been at the heart of what triggered the Reformation. During the Middle Ages the Bible that the Roman Catholic Church used was a Latin translation, known as the Vulgate. Luther, Calvin and other reformers wanted the Bible to be accessible to people in their own languages. The invention of the printing press in the fifteenth century made it possible for new translations to be made available to large numbers of people. The first complete Dutch Bible was printed in 1526. English, German and French Bibles soon followed. In 1637 a new Dutch translation, based on the original Greek and Hebrew and known as the States Bible, was published.

Although most of Rembrandt's biblical subjects had been painted by other artists, his paintings were very different from traditional Christian art. He wasn't interested in doctrine, battles over which had torn Europe apart. Instead he was interested in the drama of the stories and the characters caught up in them. He wanted to make the Bible come alive and show that its stories were universal and timeless, just as relevant in the Netherlands of the seventeenth century as they were in the ancient world.

Painting religious images could be very controversial for an artist. In 1598 Caravaggio was commissioned to paint a picture of St Matthew for the altar of a church in Rome. In an attempt to capture the difficulties

he imagined a man like St Matthew must have experienced in writing his Gospel, Caravaggio presented him with a bald head and bare, dusty feet, anxiously wrinkling his brow. An angel beside him guided his hand as he wrote, like a teacher with a child. When Caravaggio delivered the painting it was rejected as not looking enough like a saint, and he was told to produce an alternative. In his second version St Matthew looked more composed. He sported a halo, as saints traditionally did, while the angel hovered above him. This met with the approval of the church authorities.

Rembrandt too attracted criticism for his 1634 etching of *St John the Baptist Preaching*. It came from his former pupil Samuel van Hoogstraten, who felt Rembrandt had gone too far in his pursuit of realism. What troubled him was Rembrandt including a dog mounting a bitch in the composition. He thought such a depiction in a religious image was indecent.

To take stock of Rembrandt's biblical output can be overwhelming. He is thought to have produced around 160 biblical paintings, plus 80 etchings and 600 drawings. However, on closer inspection we can see certain recurrent preoccupations. There are some themes that he found himself returning to again and again. Recognizing this is important because it can provide us with valuable insights into his personal religious beliefs and his attitude to the church.

GRACE

One of the themes of the Bible that particularly attracted Rembrandt was that of the sinner and the possibility of redemption. He explored it a number of times during his career. For him, people couldn't be divided up

into sinners and saints, as some preachers of the time liked to do. That was not only simplistic but also false. People were more complex. Rembrandt saw each person as having a capacity both for goodness and for sin.

But what he was really grappling with here was the idea of God's grace, or power to transform and save a person. The action of grace does not occur because of anything the person has done. You don't earn it. Instead it's a gift from God, and one that can be given to even the most unworthy individuals.

One of Rembrandt's most powerful paintings of this theme is *Christ and the Woman Taken in Adultery*, painted in 1644. It tells the story of a woman brought before Jesus by the scribes and Pharisees because she has committed adultery. They ask him if she should be stoned to death, as the Law of Moses insists. Jesus refuses to fall into the trap they have set and tells them that the person who has not sinned should cast the first stone. When no one comes forward, he tells the woman to go away and not to sin any more.

In the painting, the woman, wearing a white garment, kneels before Christ, bathed in a pool of light. The scribes and Pharisees who surround her, waiting for Jesus to answer their question, are dressed in elaborate costumes and hats, most of which are taken from the seventeenth rather than the first century. In the background is the Temple of Jerusalem, which resembles a palace or perhaps even a Baroque Catholic church. It dwarfs the figures in the painting, especially the woman. But for all its size, gold and splendour, it is eclipsed by the light coming from the simply dressed Christ. It's worth noting that Rembrandt uses a similar composition here to that of *The Presentation of Jesus in the Temple*, painted thirteen years earlier when he had just arrived in Amsterdam.

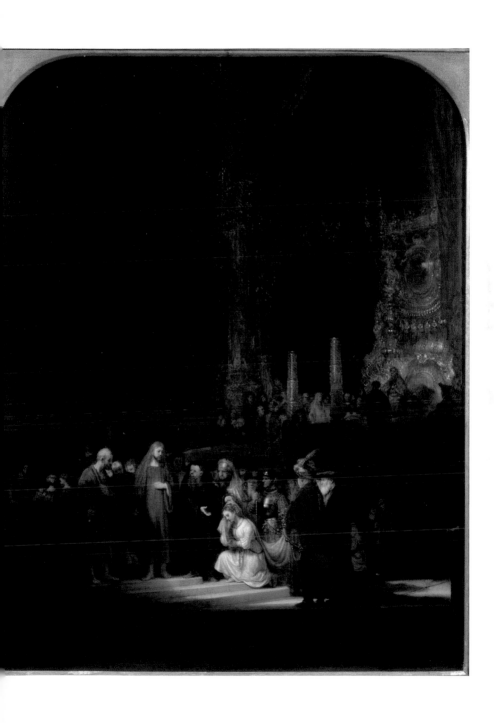

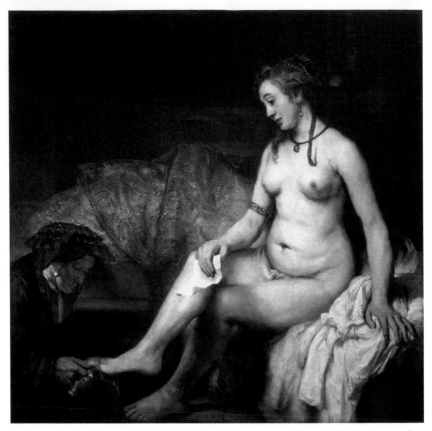

Michael Kitson points out that if Rembrandt depicts light in secular paintings, it has a visible source. But in his biblical paintings 'the natural light is fused with a supernatural radiance emanating from the figure group; yet this is done so subtly that we are only subconsciously aware of it and the way the light falls strikes us at first glance as natural'.

Another painting of divine grace being extended towards a fallen woman is *The Risen Christ Appearing to Mary Magdalene*, painted in 1638. Rembrandt depicts Mary turning around, away from the empty tomb, to see Jesus standing there, dressed as a gardener. He is wearing the kind of broad-brimmed hat that would have been popular among gardeners of Rembrandt's day.

Rembrandt explores this idea of God's grace and sin in the Old Testament by looking at King David, not only one of the most significant figures in the Old Testament, but also one of the most complex and human.

One of Rembrandt's most famous paintings is *Bathsheba Holding King David's Letter*, dated 1654. When David, looking down from the roof, spotted Bathsheba bathing in the distance, he lusted after her and had her brought to his chambers, where he seduced her. She eventually bore him a child. David committed an even more serious sin than adultery when he arranged for Bathsheba's husband, Uriah, to be sent into a battle where he would almost certainly be killed, and in fact was. The painting is thought to be based on an engraving by François Perrier. In fact, the Bible doesn't actually mention David sending a letter to Bathsheba. This is Rembrandt's addition.

In *David Sending Away Uriah* we see the sombre, dignified expression of Uriah, dressed in rich red robes and a large turban, as he leaves to do his duty in battle, in contrast to the guilt written across the face of David, who is visible behind him.

Despite David's adultery and murder, he was still used by God to do great things, not least uniting the tribes of Israel and writing most of the Psalms. Crucially, David recognized that he had sinned and sought forgiveness from God. So important was he in the story of Israel that Jesus was proclaimed as Son of David.

In *Christ and the Woman Taken in Adultery*, painted in 1648, and *The Parable of the Vineyard Workers*, painted in 1637, Rembrandt reveals a God who doesn't act in the way that people, including the religious authorities, expect. He boldly challenges their preconceptions and asks them to take a fresh look not just at the particular story but also at their own understanding of God.

Rembrandt wanted to present biblical characters, even saints, as real people. In the past artists had often portrayed them as being like

mythological figures, set apart from ordinary life. This wouldn't do for Rembrandt. It was a denial of their humanity. Moreover, he didn't believe that God only worked through the very holy.

He might have been influenced by van Swanenburgh, who had produced a series of prints of six penitent sinners in the Bible: King Saul, Mary Magdalene, Zaccheus, Judas, Peter and Paul. But it seems more likely that his fascination with sin and redemption was something that owed its origins more to Rembrandt's own psychology and religious faith.

One of Rembrandt's earliest paintings was *Anna Accused by Tobit of Stealing the Kid*. During his career he painted, etched and drew the story of Tobit over fifty times. It seems quite likely that Rembrandt turned to this subject not because of commissions but because it held some sort of fascination for him. It may have been because it reveals God's compassion. Or it may have been because the story stresses virtues such as honesty and charity. Or Rembrandt might have liked it so much because one of its themes is the love between father and son, which he also turned to in *The Return of the Prodigal Son*. Then again, there is Tobit's blindness. After getting married in a neighbouring town, Tobias goes home and cures his father's blindness. Blindness was a theme Rembrandt featured in several paintings. And we can be sure that he was thinking of spiritual blindness, not simply physical blindness.

THE DIVINE AND THE HUMAN

The encounter between the divine and the human was another aspect

of the Bible that fascinated Rembrandt. While still in Leiden he had, of course, painted the wonderfully atmospheric *Supper at Emmaus*, in which he showed how he was beginning to learn to use light and shade effectively. In the mid 1640s he painted two tender depictions of *The Holy Family* (one of them using the device of a curtain pulled to one side), and *The Adoration of the Shepherds*. In these works Mary is dressed not in blue, as artists had traditionally painted her, but in the clothes of an ordinary Dutchwoman. This was the point that Rembrandt wanted to make. Some Roman Catholic theology had elevated Mary to near divine status – one target of the criticisms of the Reformers. This was a distortion of Mary, Rembrandt believed. She was first and foremost not the mother of God, as Catholics stressed, but an ordinary woman, just like the women in the Netherlands.

One type of meeting between the human and divine that Rembrandt often painted took place through encounters with angels as messengers from God: for example, *The Angel Leaving Tobias and His Family*, dated 1637; *The Angel Stopping Abraham from Sacrificing Isaac to God*, dated 1635; *The Holy Family with Angels*, dated 1645; and *Jacob Wrestling with an Angel*, painted in the late 1650s and dated 1661.

The Evangelist Matthew Inspired by the Angel is part of a series of paintings Rembrandt did of the apostles from the late 1650s onwards. He had painted several pictures of apostles in his early years, though whether his 1628 painting *Two Old Men Disputing* is a representation of St Paul and St Peter has left art historians divided. *The Evangelist Matthew Inspired by the Angel* is a very striking and tender picture. Matthew is depicted deep in thought, staring ahead and stroking his

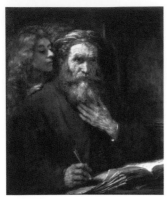

The Evangelist Matthew Inspired by the Angel, from the late 1650s.

beard. His pen is poised on the manuscript in front of him. An angel whispers into his ear, his hand resting gently on Matthew's shoulder. The idea of inspiration is something in which Rembrandt seems to have been particularly interested.

A very different representation of an apostle is *The Apostle Peter Denying Christ,* painted in 1660. Peter is in the middle of a group of people. Christ can be seen in the distance, hands tied behind his back, staring across at the man who swore never to leave him. Rembrandt was drawn to this story because it reveals how fickle faith can be, how even a person who seems to be the most devoted and loyal friend can turn to betrayal.

Rembrandt had a particular fascination with St Paul, painting him a number of times at both the beginning and end of his career. Rembrandt's 1627 painting *The Apostle Paul in Prison* was one of his earliest attempts at a single-figure history painting. Paul is not portrayed as the dynamic figure found in the Acts of the Apostles, undertaking perilous journeys around the Mediterranean world and dashing off letters to the Christian communities that had sprung up in cities such as Ephesus and Corinth. Instead, Rembrandt paints a rather worried-looking elderly man, sitting alone in his cell with the Bible on his knee. It's as if he is thinking about what fate might await him, or even questioning what his faith means to him.

The Apostle Peter Denying Christ, 1660.

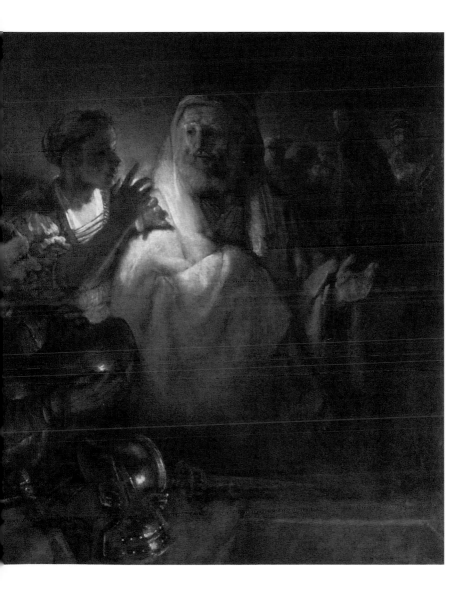

*Rembrandt's
identification with
St Paul was so strong
that he painted himself
as the apostle in 1661.*

The Apostle Paul at his Desk, painted around 1630, is a wonderful study of a man deep in thought. Whether the model is Rembrandt's father, as some suggest, is impossible to say. But what we can say is that there are resemblances to *The Evangelist Matthew Inspired by the Angel*. Both figures are staring into space, each of them holding a pen, poised to begin writing. Rembrandt's identification with St Paul was so strong that he painted himself as the apostle in 1661.

THE LAST SUPPER

Leonardo da Vinci's painting *The Last Supper* was regarded in Rembrandt's time, as now, as a masterpiece. Rembrandt had bought a print of it at an auction and done a drawing of it. But, despite his fascination with stories from the Bible, that was the only time he ever attempted the subject.

Kenneth Clark claims that this was because Rembrandt felt that 'Leonardo had done that once and for all'. Nevertheless 'it was always at the back of his mind, and an attentive eye can see memories of Leonardo's masterpiece appearing in pictures, etchings and drawings all though his life'. Two of Rembrandt's paintings that borrow from *The Last Supper* are *Samson's Wedding*, which depicts Delilah in the position of Christ, set apart from the others sitting at table with her; and the version of *The Supper at Emmaus* that was painted in 1648, in a more traditional style than the earlier version which deployed light and shadow so effectively. But given Rembrandt's sense of himself as someone following in the footsteps of the great masters and trying to

The Last Supper, after Leonardo da Vinci,
1634–35.

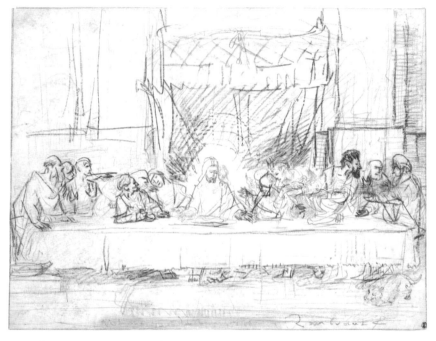

equal, or even surpass, what they had achieved, it's surprising that he
would have thrown in the towel when it came to *The Last Supper*.

BELSHAZZAR'S FEAST

In the 1630s Rembrandt drew heavily on the Old Testament, particularly
the book of Tobit and stories about Samson. But his most extraordinary
Old Testament painting was *Belshazzar's Feast*, taken from the book of

Daniel. Dated 1636, it was painted around the same time as he was working on the passion series for Prince Frederik Hendrik. It is one of Rembrandt's most memorable and dramatic paintings, and perhaps his most theatrical.

Belshazzar was a king of Babylon who gave a banquet for a thousand of his nobles, their wives and his concubines. He ordered that the gold and silver goblets his father Nebuchadnezzar had stolen from the Temple in Jerusalem be filled with wine. As the guests all drank, they praised their gods of gold, silver, bronze, iron, wood and stone. Then suddenly the fingers of a hand appeared and wrote something on the wall. Belshazzar was terrified and wanted to know what the writing meant, so he summoned his wizards, diviners, astrologers and magicians, and promised to make the one who could explain the writing the third most important person in his kingdom. When none of them were able to understand the writing, the queen told him to call for Daniel, a young Jew exiled in Babylon who was known for his wisdom.

Belshazzar's Feast, 1636.

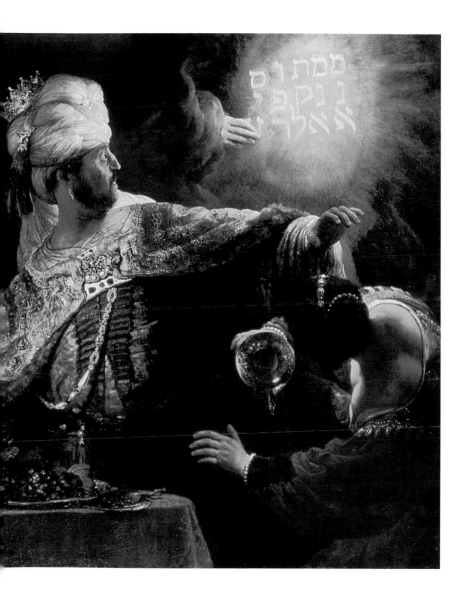

Daniel was brought before the king, who promised to make him the third most important person in the kingdom if he could tell him what the words meant. Daniel said that he would explain them, but added that he didn't want any reward. The message said that God had numbered Belshazzar's days because he 'had been weighed on the scales and found wanting', and that his kingdom was to be given to the Persians and Medes. That same night, Belshazzar was killed.

Rembrandt produced an unforgettable painting. With his outstretched arms, richly decorated gold cape, large turban and glittering crown perched on top, beady eye and pointed nose, Belshazzar resembles some kind of giant exotic bird. As Rembrandt is unlikely to have known Hebrew, the Hebrew writing on the wall was probably provided by one of his Jewish friends, most likely his neighbour Menasseh ben Israel.

Simon Schama describes the painting as one of Rembrandt's most flamboyant and electric, and writes, 'Faithful to the biblical message, Rembrandt has gone all out to suggest the perishability of things: precious metals, the pleasures of appetite, the longevity of empires.'

But for whom exactly were *Belshazzar's Feast* and Rembrandt's other biblical pictures painted? Unlike the Roman Catholic provinces of the southern Netherlands, where Rubens prospered, the United Provinces had no market for paintings to decorate churches. The Reformed Church and other smaller Protestant groups rejected visual imagery in their worship. Given that Protestantism in the Netherlands was not strict and lacked the kind of doctrinal authority wielded by the Catholic Church, it's quite likely that some of Rembrandt's biblical paintings were commissioned, or at least bought, by merchants who wanted images to nourish their Christian faith,

or simply to provide an interesting feature in their homes. Seymour Slive thinks that Rembrandt painted many of his biblical paintings to meet his own inner needs.

The most we can say is that perhaps Rembrandt viewed his biblical paintings as ways of both earning a living and of helping him to explore his ideas about spirituality and God. And he would have seen no conflict between the two. He never embraced dualism, the idea popular with some Christians that the material and spiritual are not parts of a single whole but completely separate.

JEWS

Rembrandt seems to have been good friends with Menasseh ben Israel, an influential Portuguese Jew who lived in the Breestraat. He was not only the rabbi at a synagogue near van Uylenburgh's house but also a writer and scholar who had taught the philosopher Spinoza. And he was one of the first printers of Hebrew in Holland. Rembrandt produced an etched portrait of him in 1636, and also provided four illustrations for his book *The Illustrious Stone, or The Statue of Nebuchadnezzar*, which dealt with the end times. Ben Israel eventually left the Netherlands for England, to plead with Oliver Cromwell for the Jews, who had been excluded from the Commonwealth, to be allowed to return. He believed that England's ban on Jews was hindering the coming of the messiah.

With its general air of tolerance, Amsterdam had become home to a thriving Jewish community, many of whom were intellectuals or businessmen. Most Jews in the Netherlands were Spanish or Portuguese

(Sephardim), or Ashkenazim from northern Europe. In his etching of Jews in a synagogue Rembrandt gives us a glimpse into their life in Amsterdam.

WHAT DID REMBRANDT BELIEVE?

So what of Rembrandt's personal religious faith? Given his emotional response to biblical stories there can be no doubt that he was a Christian. He is involved with those stories in a way that someone who did not believe in God and the Christian story could not be. What's more, in the seven letters he wrote to Huygens about the passion series he uses devotional language, phrases such as 'heavenly blessings' and 'Amen'.

But to what sort of Christianity did Rembrandt subscribe? The fact that he painted Calvinists, Mennonites, Roman Catholics and Jews would suggest that he had a liberal approach to faith and probably little interest in the battles over dogma that divided Christians. He certainly seems to have held no anti-Catholic views. He had, of course, grown up in a mixed Calvinist/Catholic family, had been trained by van Swanenburgh and Lastman, who were both Catholics, and had painted a number of Catholics, for example the shipbuilder Jan Rijksen and his wife Griet Jans. He even painted his son Titus wearing the habit of the Franciscans.

Robert Wallace suggests, 'The stern, implacable God of the Calvinists was not credible to him; he never painted a Last Judgment, and he shunned apocalyptic themes. He was the loving, forgiving God of the New Testament.

The letter-strict morality of the Calvinists was also foreign to him. He did not ridicule it; he ignored it.'

It's frequently argued that the group with which Rembrandt felt the strongest affinity were the Mennonites. Kenneth Clark says that from about 1640 onwards all Rembrandt's paintings could be seen as illustrating Mennonite beliefs. The Mennonites took their name from Menno Simons, a priest who left the Roman Catholic Church because he could no longer accept some of its teaching, particularly on infant baptism and the eucharist, and began travelling around northern Europe preaching to Anabaptist communities.

The Anabaptists were a loose group of movements that had sprung up during the Reformation. They believed in mutual aid and the redistribution of wealth (Rembrandt doesn't seem to have subscribed to this particular doctrine), a rejection of oaths, adult baptism, non-violence and the imminent return of Christ. They believed church and state should be separate and rejected the ecclesiastical structures and authority that were the hallmarks of the Catholic Church, seeking to return, as they saw it, to the simple model of the church described in the Acts of the Apostles. But the Anabaptists found themselves under attack from both Catholics and Protestants, who saw them as dangerous heretics; thousands of them were put to death, either by fire in Catholic territories, or by drowning or the sword.

For a man of Rembrandt's sensibilities, the more radical Mennonite version of Christianity would have had more appeal than Calvinism. He knew many Mennonites, including van Uylenburgh, who may have introduced him to others in Amsterdam. For example, he seems to have

What Rembrandt's biblical paintings, drawings and etchings give us is not a presentation of one particular type of Christianity but rather a window into the supernatural workings of God.

been friends with the cloth merchant Cornelis Claesz Anslo, a Mennonite preacher and theologian, who was a member of the Waterlanders, a liberal group, and took part in debates with Baptists. In 1641 Rembrandt etched his portrait and painted a double portrait of him with his wife.

Some have argued that Rembrandt was the first painter to convey the spirit of an enlightened Protestant Christianity. It could be said that Rembrandt was preoccupied with the ideas of the fatherhood and compassion of God and the tenderness of Christ.

What Rembrandt's biblical paintings, drawings and etchings give us is not a presentation of one particular type of Christianity but rather a window into the supernatural workings of God. Robert Wallace says, 'In his religious paintings, during his transition from youthful exuberance to the calm reflectiveness of middle age, Rembrandt became more and more concerned with the inner reactions of the individuals he portrayed rather than their outward actions.'

Rembrandt's personal crises in the 1640s only strengthened his faith and spurred him on to create a world of warmth and intimacy, says Wallace, which can be seen in his depictions of the holy family.

Many would agree with Kenneth Clark when he says, 'Rembrandt tried, more than any artist who has ever lived, to express all that he sensed about God and man – suffering, endurance, love, redemption, even history.'

Rembrandt seems to have been able to get under the skin of all types of men and women, and to know how they would behave in any given situation. This makes his illustrations of biblical stories so different from anything that had been done before. He entered into the spirit of the

episodes, attempting to visualize exactly what the situation must have been like, and how people would have behaved.

For Rembrandt, the people he read about in the Bible were no different from the people he saw and met in the streets of Amsterdam. What he wanted to do in his paintings was to bring the stories in the Bible alive. He retold them highlighting what he saw as the true message, which was nearly always that the natural world co-existed with another world, the supernatural world. Rembrandt had a mystical side to him. As well as this, one of the lessons he wanted to teach was that even those who commit the biggest sins, such as King David, St Paul or St Peter, are not beyond redemption, because the divine spark is in each person. In some it glows more brightly than in others, but it is still there in everyone.

Chapter 7
MONEY

By the late 1640s Rembrandt was well into middle age and one of the most celebrated artists in the Netherlands, despite his star having fallen at court as a result of the delays to the passion series. He had more than fulfilled the promise he showed as a young artist in his home town of Leiden, trying to imitate his master van Swanenburgh. But behind this outward appearance of success, there was another story. He was having serious problems in his private life and also with his finances.

It was around this time that he found a new woman in his life, Geertje Dircx, who was his son Titus' nursemaid. Small and plump and from a peasant background, she came from Edam and was the widow of a ship's trumpeter. She seems to have worked as a housekeeper and waitress before landing a job in Rembrandt's household.

Some time after Saskia's death in 1642 Rembrandt began an affair with Geertje. Whether she was already employed while Saskia was alive is unclear. Rembrandt was clearly smitten by her, as he gave her presents and some of Saskia's jewellery. However, the relationship turned sour for some reason, and in 1649 it seems he forced Geertje to leave his home and move into a rented room.

On 25 September 1649 Rembrandt was ordered to appear before the Commissioners of Marital Affairs and Damage Claims. Geertje claimed that Rembrandt had promised to marry her. In January 1648 she had made a will in which she left all her possessions, except for her clothing, to Titus. This would suggest that she was telling the truth. Rembrandt didn't turn up. He knew that if he remarried he would have to forfeit the income he received from Titus' inheritance, as laid down by Saskia's will. The fact that

he painted nothing in that year suggests that the bitter dispute with Geertje must have taken its toll on him.

He eventually made her an offer of 160 guilders plus 60 guilders a year for the remainder of her life. This was on condition that she didn't change her will. She must have rejected this, because in October Rembrandt made a second offer of 200 guilders in cash and 160 guilders a year, once again emphasizing that she must not change her will. It appears that Geertje agreed to this and they met in Rembrandt's house to sign a legal document. But then she changed her mind and refused to sign it.

When Rembrandt was summoned again to appear before the commissioners, he once again failed to turn up. A third summons followed, and this time he did appear. The Commissioners' Book of Disputes records:

> *The plaintiff declares that the defendant made an oral promise to marry her, in token of which he gave her a ring; she said moreover that he slept with her more than once; she requests that she may be married to the defendant, or otherwise be supported by him.*
>
> *The defendant denies having promised to marry the plaintiff, declares that he is under no obligation to admit that he slept with her, and adds that the plaintiff would have to come with proof.*

The commissioners decided to increase Geertje's annuity to 200 guilders, while approving the legal document that she had refused to sign.

In April 1650 Geertje gave her brother Pieter Dircx and her nephew Pieter Jacobsz power of attorney to collect her debts. However, her brother turned against her and made an agreement with Rembrandt. He and

his cousin hired a neighbour of Geertje's to take statements from other neighbours about her lifestyle suggesting that she was of unsound mind. As a result, she was sent to the house of correction in Gouda for twelve years. As Rembrandt paid the costs of the hearing, we have to assume that he was behind this plan.

Rembrandt must have felt very angry about Geertje's actions, because, the following year, he sent Cornelia Jansdochter to Geertje's former home in Edam to gather more evidence against her. This time, though, the friends and relatives who were approached refused to co-operate. It seems they had been unaware that Geertje had been taken away. Instead, they began to try and get her released from the house of correction.

Much to Rembrandt's dismay, Geertje was freed in 1655 after spending five years locked up. The following year, after Rembrandt had failed to make his payment to Geertje, another round of litigation began. But the legal wrangling ended when Geertje died later that year.

HENDRICKJE STOFFELS

The woman who replaced Geertje in Rembrandt's affections was Hendrickje Stoffels, who had been a maid in his house and was twenty years younger than him. The fact that she gave evidence against Geertje to the Commissioners of Marital Affairs and Damage in 1649 suggests that she and Rembrandt must have already had a close relationship by then. If they did, then this would explain why Geertje became so acrimonious towards Rembrandt. For him to break a promise to marry her was one thing, but to break it because he had found another woman would have been another matter.

Hendrickje came from a simple family in the garrison town of Bredevoort in the eastern Netherlands. Her father and brothers were all in the army. She had grown up in a very different kind of environment from the cultured Saskia.

For a couple to be living together and not married was seen as scandalous in seventeenth-century Netherlands. And on 25 June 1654 Hendrickje was summoned before the Reformed Church council to face charges that she 'practised whoredom with Rembrandt the painter'. She failed to appear. Two more summonses followed and she ignored those as well. Being a poorly educated girl, she must have been alarmed and worried to receive letters from the church council, even though their power was, in reality, very limited. So we can only assume that her failure to respond was down to Rembrandt, who had shown a similar disregard for authority when the commissioners had ordered him to answer questions about his relationship with Geertje. If we want to know exactly what Rembrandt must have thought of the church council's accusation against Hendrickje, then we only have to look at his painting of *Christ and the Woman Taken in Adultery*.

Nevertheless, Hendrickje did eventually appear before the church council, in July, and confessed to the charges put to her. She was admonished, urged to repent and barred from attending the Lord's Supper. Given that she was probably only a lukewarm member of the church, this was not much of a penalty. Rembrandt must have known the likely outcome of the hearing, and is unlikely to have been too bothered about it.

Three months later Hendrickje gave birth to a daughter, Cornelia, named after Rembrandt's mother. As their relationship had now been

cemented by the birth of a child, we might have expected Rembrandt to marry Hendrickje. But he didn't.

The reason for this might have been, as with Geertje, that under the terms of Saskia's will he could not marry again without losing all claim on her dowry. If Titus had died, that meant he would have had to give Saskia's inheritance back to her family. Rembrandt must have weighed up the pros and cons of marriage and money and come down firmly on the side of money.

Rembrandt never painted a formal portrait of Hendrickje as herself, as he had done with Saskia. However, she appeared as a model in several of his paintings. For example, she was the model for *Bathsheba Holding King David's Letter*, and also for *A Woman Bathing*, dated 1654.

BANKRUPTCY

The long drawn-out episode with Geertje cast a shadow over the first half of the 1650s for Rembrandt. He must have found it an annoying distraction from his work. But worse was to come.

Rembrandt seems to have maintained a steady income. For example, for the five paintings of the passion that he provided for Prince Frederik Hendrik in the 1630s he was paid 600 guilders each, a hundred times more than he would have got on the open market. Between 1631 and 1635 he painted about fifty portraits, and is thought to have charged between 50 guilders for a single head and 500 guilders for a full-length, life-size work.

If he had handled the commission from Prince Frederik Hendrik better, and delivered his paintings on time, then he might have easily

Hendrickje was the model for
A Woman Bathing, 1654.

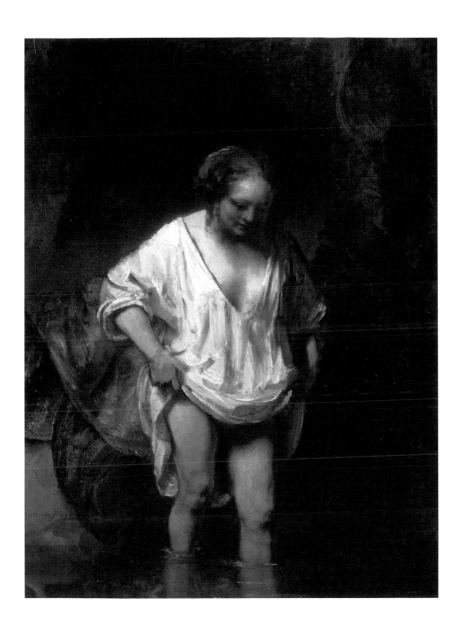

enjoyed a healthy income from the court. And this could have prevented the kind of problems he was now facing.

Rembrandt's outgoings were high. He had Hendrickje and their child to support, a large house to maintain, a maid and possibly other staff to pay, and all his artist's materials to buy. He'd also had to support Geertje. As well as all of this, he had to finance his passion for buying art and curiosities at Amsterdam auction houses.

Some have suggested that the downturn in the Dutch economy, due to the first war between the Netherlands and England, caused by disputes over trade, might have had something to do with Rembrandt's downfall. This seems unlikely, as there is no evidence that Rembrandt invested his money in the great Dutch shipping companies. The only thing he invested in was art. That was what he knew best.

The fact is that he was living beyond his means and he had failed to pay for the house he had bought in 1639. In 1653 Christoffel Thijs presented Rembrandt with a bill for 8,470 guilders owing on the house he had bought from him. Thijs had, in fact, paid some of the taxes Rembrandt owed. But his patience now ran out.

Rembrandt borrowed two sums of 4,000 guilders from Isaac van Heertsbeeck and Cornelis Witsen, plus 1,000 guilders from Jan Six, promising to pay each of them back within a year. But he didn't. He had sunk too far into debt. He was well behind with his mortgage repayments, owed taxes and had borrowed money from a number of friends and associates.

Why a painter as successful as Rembrandt ended up in such dire straits has been the subject of much debate over the years. Kenneth Clark

concludes, 'It is hard to say why he fell so deeply into debt: what with his own earnings and Saskia's dowry and his fifty pupils, he could have been perfectly solvent.'

The root of his problem was that he never paid for his house. According to the terms he had signed when he bought it in 1639, it should have been paid off by 1646. In January 1653 he still owed 8,000 guilders of the principal, 1,137 in interest and 333 in taxes. Pressure was put on Rembrandt to pay.

He realized that there was only one way out: to sell some of his paintings and other possessions. Just before Christmas 1655, he held an auction at the Emperor's Crown Inn. However, he didn't use any of the money he made to pay his creditors.

Unsurprisingly, this did nothing for Rembrandt's reputation for keeping his word. His friend Jan Six asked for his 1,000 guilders to be repaid. When Rembrandt told him he didn't have it, Six promptly sold the debt to Gerbrand Ornia, who became the first creditor to take action against Rembrandt.

Rembrandt tried to buy another house in the Handbooghstraat. He attempted to obtain a mortgage for 4,000 guilders, offering paintings and etchings worth 3,000 guilders as a down-payment. But the deal fell through. It seems likely that this move into the property market was not because he wanted a second home but because he wanted somewhere smaller, and therefore cheaper, to live.

Around this time, he became involved in a dispute with a Portuguese merchant, Diego Andrada, who had ordered a portrait of a young girl and given Rembrandt a 75-guilder deposit. He was unhappy with the portrait,

saying it wasn't an accurate likeness, and asked Rembrandt either to rework it or give him back his money. Rembrandt told him that he would submit the painting to the Guild of St Luke for their opinion. We don't know how the matter was resolved.

This wasn't the first time Rembrandt had been accused of shady business practices. In 1637 he had got into trouble with the law. He had sold one of his etchings, of Abraham and Hagar, to the Portuguese Jewish painter Samuel d'Orta and had agreed with d'Orta that he wouldn't sell the three or four prints of the etching that he had, or any other prints from the etching, to anyone else. D'Orta believed that Rembrandt hadn't kept his word.

Gary Schwartz claims Rembrandt bought a Rubens from a Catholic accountant in an illegal manner by making false bids in an auction house to boost the prices of the paintings. For this he was paid two and a half guilders and given an opportunity to buy the Rubens outside the auction.

Given his contacts in Amsterdam, it would be surprising if Rembrandt hadn't sought legal advice over his financial situation. In May 1656, he made a smart move by transferring ownership of the house to fourteen-year-old Titus and getting him to make a will, leaving everything to him and nothing to Saskia's family.

A few weeks later, Rembrandt applied to the High Court in The Hague for a form of insolvency known as *cessio bonorum* (he produced an etching of the bailiff of the court, Jacob Haaring). This meant he would have to give up ownership of all his property and any benefits would go to his creditors, who would have no further claim on him after this. And he would avoid

the possibility of being sent to prison. Technically he was insolvent but in reality he was bankrupt.

From the inventory drawn up by the secretary of the Insolvency Court, we get a fascinating peek into Rembrandt's world. The list of 363 items includes 49 of Rembrandt's own paintings, categorized as history, figures, heads, landscapes, animals and still lifes, and various. In addition there are eight paintings 'touched up' by Rembrandt and numerous drawings and prints, most of them in books.

There are dozens of paintings and drawings and prints by other masters. The Dutch and Flemish artists include Jan Lievens, Pieter Lastman, Adriaen Brouwer, Anthony van Dyck, Hercules Seghers, Abel Grimmer and Johannes Porcellis. Rembrandt also had works by the Italian masters Raphael, Michelangelo and Annibale Carracci, and by the German Lucas Cranach the Elder. As well as all these, there are paintings, prints and drawings by anonymous artists. Also listed is a painting of three small dogs by his son, Titus.

These possessions – really the tools of his trade – also include over thirty statues, busts, masks, thirteen books (interestingly, only one Bible, listed as an old one), pistols, thirty-three antique handguns, sixty Indian guns, a small metal cannon, bows and arrows, shields, swords, helmets, a catapult, musical instruments, plants, pieces of coral, lion skins, an Indian cup, an East Indian sewing box and a Chinese basket.

His household effects include four Spanish chairs with Russian leather, a walnut table, an oak cupboard, two globes, a brass kettle, an old trunk, a pewter water jug, 'a very antique chair', 'a few pots and pans', three men's shirts and some collars and cuffs.

But even after Rembrandt's house and possessions had been sold, he still owed money. The sale of his house in 1658 raised only 11,218 guilders, nearly 2,000 guilders less than he had paid for it, while his collections and personal effects brought in only around 5,000 guilders. Legal actions from creditors dragged on for several years.

This must have been a very humiliating episode for Rembrandt. How could he, one of the most talented and praised painters ever to emerge in the Netherlands, an artist who had won commissions from Prince Frederik Hendrik, lose everything, even his house? What's more, he was responsible for a teenage son, a small daughter and a lover. We can only guess at the kind of thoughts that must have run through his mind.

Despite knowing that he was heading for financial disaster, Rembrandt still managed to produce some outstanding paintings. Two in particular are worth mentioning, *Titus at His Desk* and *The Polish Rider*, both painted in 1655. Titus would have been fourteen when the former was painted. Rembrandt has depicted him sitting at a desk, studying. He is deep in thought, gazing at the floor. The painting bears similarities to *A Young Girl at a Window*, painted four years before.

The Polish Rider has attracted much speculation, but its meaning has eluded art experts. Some have suggested it is an equestrian portrait, others that the young rider is meant to represent a Christian knight. His costume appears to be eastern European.

The following year Rembrandt returned to the group portrait, which was, of course, very lucrative because each subject paid individually to appear. *The Anatomy Lesson of Dr Deyman* is similar to *The Anatomy Lesson of Dr Nicolaes Tulp*, painted in 1632, the work which really kicked off

Rembrandt's career in Amsterdam. Deyman had succeeded Tulp as head of the surgeons' guild.

The kind of financial disaster Rembrandt experienced was not unusual among artists of his time in the Netherlands. For example, the prolific landscape painter Jan van Goyen, who worked first in Leiden and then in The Hague, hit the same kind of financial disaster as Rembrandt. In his case, he had lost money speculating in tulips and real estate, and was forced to sell his house when he went bankrupt. He died in 1656, leaving behind huge debts. Frans Hals frequently owed money to his baker and his shoemaker. He spent his last years in Haarlem penniless, living on a small income from the municipal almshouses, whose board of governors he had painted. And it is said that at the time of his death in Delft, where he spent his whole life, Johannes Vermeer left an unpaid baker's bill of 617 florins. The baker agreed to accept two portraits instead of payment.

The fact is that making a living as an artist in the Netherlands was not easy. Many artists in those days, as today, found it a struggle to obtain a steady supply of commissions or sell enough of their work. Artists could make big money: Jan van Goyen was paid 650 guilders by the town council for his *View from The Hague*, while Ambrosius Bosschaert received 1,000 guilders for a flower painting. In 1646 Frederik Hendrik paid Rembrandt 2,400 guilders for the *Adoration of the Shepherds* and a *Circumcision*. But these paintings could take a long time to produce – in Rembrandt's case sometimes a very long time.

Charles L. Mee says that only a few painters in the Netherlands made a living from their work. A painting by Abraham van Beyeren fetched

The Polish Rider, 1655, whose meaning has baffled art experts.

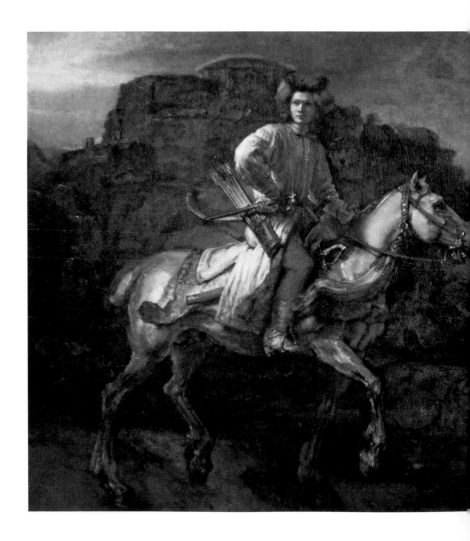

only twelve guilders when it was raffled, while Benjamin Cuyp's large biblical and cavalry scenes would only sell for fifteen to seventy guilders. Artists often had to take on other jobs. Jan Steen ran an inn, Johannes Vermeer ran his father's tavern, Jan van Goyen worked as an estate agent, and Karl van der Pluym became a plumber.

E. II. Gombrich highlights some of the problems painters faced. 'The painters of Protestant Holland who had no inclination or talent for portrait painting had to give up the idea of relying chiefly on commissions. Unlike the masters in the Middle Ages and of the Renaissance, they had to paint their pictures first, and then try to find a buyer.' He adds that artists either had to go to the market-place and to public fairs to sell their works or had to rely on picture dealers, who wanted to buy as cheaply as possible in order to be able to sell at a profit.

And, of course, in the seventeenth-century Netherlands there was so much competition around. At the time of Rembrandt's bankruptcy some of the great names who had been working when he began his career had died. These included the Flemish masters Rubens and van Dyck, Hendrick ter Brugghen and Gerrit van Honthorst. But a new wave of outstanding artists had taken their place, among them Jan Steen, Gerard ter Borch, Pieter de Hoogh, Jacob van Ruisdael and Johannes Vermeer.

According to Sandrart, Rembrandt sometimes had as many as twenty-five pupils, which would have brought him in

2,500 guilders a year in fees. At the same time, however, he was creating more competition in an already crowded market.

Two of his most successful students were Govaert Flinck and Ferdinand Bol, who had both become leading history painters. When the Netherlands and Spain signed the Treaty of Westphalia in 1648, ending what was later to be known as the Eighty Year War and confirming the Netherlands as a republic, it was Flinck rather than Rembrandt who was invited to paint the militia celebrations. Two years later he beat Rembrandt again when he was commissioned to paint Amalia van Solms mourning for Prince Frederik Hendrik. Rembrandt had, of course, painted her in the 1630s, but that was when he was in favour at the court. Meanwhile, Bol had received numerous commissions from wealthy Amsterdam merchants and had also provided paintings for the town hall.

Rembrandt's money problems could also have been caused, in part at least, by his obsession with curiosities. The items listed in the inventory must have cost a fortune when added together. His collecting may have even become an addiction. If this was the case, then, like any addiction, it could have easily gained control over his spending habits. Baldinucci wrote of Rembrandt:

> He often went to public sales by auction: and here he acquired clothes that were old-fashioned and disused as long as they struck him as bizarre and picturesque, and those even though at times they were downright dirty, he hung on the walls of his studio among the beautiful curiosities which he also took pleasure in possessing, such as every kind of old and modern arms – arrows, halberds, daggers, sabres, knives and so on – and

Adoration of the Shepherds, 1646, for which Rembrandt was paid 2,400 guilders.

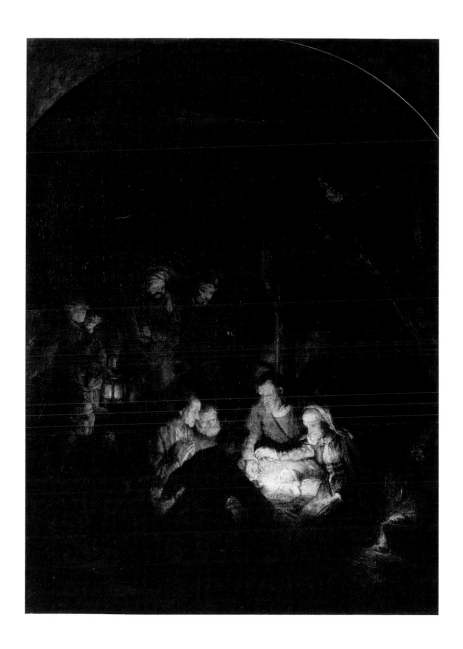

innumerable quantities of exquisite drawings, engravings and medals,
and every other thing which he thought a painter might ever need.

And Robert Wallace says, 'His imagination was stimulated by the mere sight of an outlandish turban, a golden helmet or a rich brocade; with the aid of these he was able to transport himself across space and time without plunging himself in books or journeying farther than the auction room.'

Rembrandt liked nice things and a comfortable life. That's pretty clear. He was an artist, not a businessman. But in order to keep his finances in order he needed to have a good business mind. And unfortunately, he didn't. That was the cause of his downfall.

Chapter 8
DRAWINGS AND ETCHINGS

Aside from his paintings, Rembrandt produced a huge number of drawings, etchings and engravings. There are said to be around 1,400 drawings by Rembrandt in existence today. He produced so many that a special auction of them was held at an inn in 1656 as part of his bankruptcy proceedings. Rembrandt's inventory lists a number of albums and collections of drawings.

Artists did drawings for several reasons. Sometimes they were no more than loose sketches of ideas, preparation for paintings; sometimes they were done to show a patron the outline of what the artist intended to paint. We have drawings of major commissions such as *The Anatomy Lesson of Dr Nicolaes Tulp* and *The Night Watch* – but none for *The Sampling Officials of the Drapers' Guild*. This could be, however, because they were lost. While some of Rembrandt's drawings were a preparation for his paintings, many were works in their own right. His drawings include subjects that rarely appeared in his paintings: women with children, domestic scenes, animals, birds, landscapes and town views.

In his book *Rembrandt Drawings*, Bob Haak tells us, 'There are certain drawings that might be interpreted as preparatory studies for a total composition, except for the fact that no direct connection with any painting can be demonstrated. The great majority of these should probably be regarded as ideas that never got worked out.'

Rembrandt usually used small sheets of white paper for his drawing, and sometimes, as the inventory from his bankruptcy reveals, sketchbooks. He worked mainly in black and red chalk and pen-and-ink, often in brown, and drew with goose quill and reed pens, using brushes to wash drawings and also to draw with. Most of his drawings are done with bold strokes.

Before the pupils of painters learned to paint they had to learn to draw. And often they would make copies of drawings by their masters. In a book called *Introduction to the Advanced Study of the Art of Painting* Samuel van Hoogstraten, a former pupil of Rembrandt, described the tasks pupils would be expected to perform, 'Usually the pupils are set to copying eyes, noses, mouths, ears, and various faces, and further, prints of all sorts... In order to learn a good method, it is of great advantage to copy extremely fine drawings very early; for thus does one find in a short time what another long sought for.'

Life-drawing classes were an important part of the training an artist provided for his pupils. Many female nude models were prostitutes. Govaert Flinck is said to have used the van Wullen sisters, who ran a house of ill repute. Ordinary Amsterdam women would never consider posing nude, as it would cast doubt on their reputation.

Rembrandt drew and etched nudes throughout his career, such as *Female Nude Asleep* in 1657–58 and *Reclining Nude* in 1659. His etchings include *Naked Woman on a Mound* in 1631 and *Woman at the Bath with a Hat Beside Her* in 1658. After Rembrandt's death, theatre critic Andries Pels attacked his etching of *Naked Woman on a Mound*, arguing that the painter used for his models 'no Greek Venus; but sooner a washerwoman or a peat trader from a barn, calling his error imitation of Nature, all else vain ornament. Weak breasts, disfigured hands, even the marks of the laces of the corset on the stomach, of the garter on the leg, all must be copied for nature to be satisfied.'

Pels was right. Rembrandt didn't choose to portray women who met the classical ideal of beauty. Instead he depicted very ordinary women,

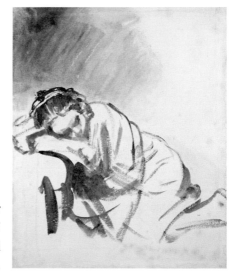

A Young Woman Sleeping,
c. 1654.

the kind of women he knew or would have seen in the streets of Amsterdam. He wasn't interested in perfection. That was a myth. He was only interested in reality. And as for beauty, that went much deeper than a woman's outward appearance.

Rembrandt produced a number of drawings of Saskia in the 1630s: in one she is looking out of a window, in another she is sitting up in bed. He also drew her sister Titiana, who spent a lot of time with her when she was unwell.

In the 1630s Rembrandt also captured some beautifully observed moments from motherhood and childhood, notably in *The Naughty Child, Woman Carrying a Child Downstairs* and *Woman with a Child Frightened by a Dog.* His 1646 drawing *Study of a Woman Teaching a Child to Walk* is a continuation of this theme.

Rembrandt painted very few landscapes (although he did incorporate landscapes into some of his biblical paintings), but he drew dozens of scenes of Amsterdam and the surrounding countryside, along with the nearby town of Rhenen. He was particularly attracted to the River Amstel, farmhouses and windmills. His 1647 scene *The West Gate of Rhenen* and his 1652 drawing of the ruins of the town hall after a fire are two of the few drawings he did solely of buildings.

Given his output of biblical paintings, it's no surprise that Rembrandt produced dozens of drawings of Bible stories. Many of these scenes, such as *Christ Among the Doctors, Christ Walking on the Waves, Christ and the Woman of Samaria* and *The Good Samaritan Arriving at the Inn,* never became the

subjects of paintings, but their themes are often the same: grace, moments of divine revelation, forgiveness and compassion.

In Rembrandt's drawings we would expect to see family scenes, landscapes and biblical subjects. We wouldn't expect to see lions, camels and elephants, but we do. It's quite likely that he saw these wild animals in the travelling circuses that were popular in the Netherlands. Nor might we expect to see *Four Dervishes Seated Beneath a Tree* and *The Emperor Hahangir Receiving an Address*. But Rembrandt had a fascination with the East, which was being explored by the Dutch fleets that returned to Amsterdam with all manner of exotic items. We only have to think of the number of times Rembrandt dressed characters in his paintings in eastern-style hats and robes.

ETCHINGS

To keep up with the huge demand for art, and to boost their income, artists produced prints of their work, either through engravings or etchings. This was an early form of mass production and a quicker and easier way for artists to make money than through paintings.

An engraving was done by cutting lines into a metal plate, usually made of copper, with a thin, diagonally sharpened steel rod called a burin. An engraving could produce far more prints than an etching, typically 300 good ones and another 300 reasonable ones. This made them cheaper and more within the reach of the lower classes.

With etchings, a plate was covered with a protective coat of resin and the artist then scratched the design with a needle and immersed the plate in a bath of acid. Using a needle allowed the artist to create more

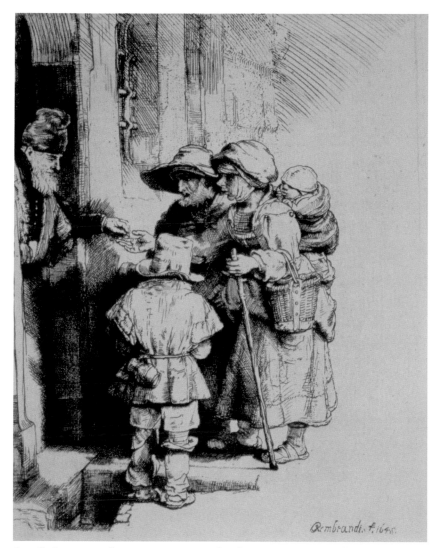

detail than in a drawing. Because the lines were very lightly scratched, each time a print was made it wore away the image a little. Around 50 good prints and another 200 reasonably good ones could be produced this way.

It might be true, as some historians have suggested, that because Rembrandt was concerned with the quality of his prints he became dissatisfied when they began to fade and didn't produce as many as he could have done.

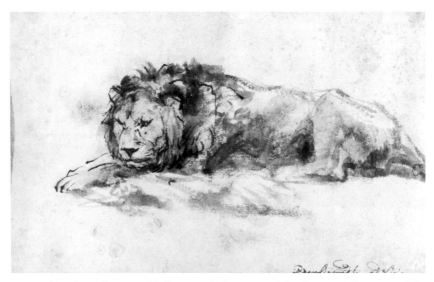

Rembrandt was widely regarded as one of the finest and most prolific etchers in the Netherlands. In fact many would have been more familiar with him through his etchings than his paintings. This was because he produced hundreds of etchings during his career, none larger than 53 cm by 45 cm. It's possible, at least in his early days in Amsterdam, that the enterprising van Uylenburgh may have published them.

One of Rembrandt's most famous etchings is *Christ Healing the Sick*, known as *The Hundred Guilder Print*. The print is not dated, but is thought to have been produced in the early to mid 1640s. Christ, his hands raised, stands in the middle of a motley collection of men and women. An old woman kneels before him in a posture of supplication. At his feet, another woman lies on a stretcher. Others look on with a mixture of emotions.

Some seem transfixed by Christ, others show little interest. The camel in the archway is a reminder of Christ's saying that it is easier for a camel to pass through the eye of a needle than for a rich man to enter the kingdom of heaven.

Other scenes Rembrandt etched from the Bible included the circumcision, the flight into Egypt, Christ's agony in Gethsemane and the entombment. He depicted the raising of Lazarus twice, in 1631 and again in 1641.

Rembrandt's largest etching was *The Three Trees*, done in 1643. It shows his great talent for creating an atmosphere, and also that his lack of interest in depicting landscapes had nothing to do with lacking the talent. While the trees dominate the scene, he has added other details, such as a fisherman with his line and his wife with a lunch basket, two lovers in the undergrowth, a wagon, cows, horses and people in fields. Historians are divided as to whether the three trees represent the three crosses on Calvary. But Rembrandt must have been aware of the Christian symbolism of including three trees as opposed to, say, two or four.

One of his most daring etchings was of a monk and a peasant woman fornicating in a field. However, this should not be seen as an attack on the Roman Catholic Church. There is no evidence of Rembrandt having the kind of anti-Catholic view that some held in the Netherlands. This drawing is nothing more than an observation on humanity, albeit a rather unexpected one.

According to Edmé François Gersaint, an eighteenth-century art dealer who compiled the first catalogue of Rembrandt's paintings, Rembrandt was at dinner with Jan Six when it was discovered there was

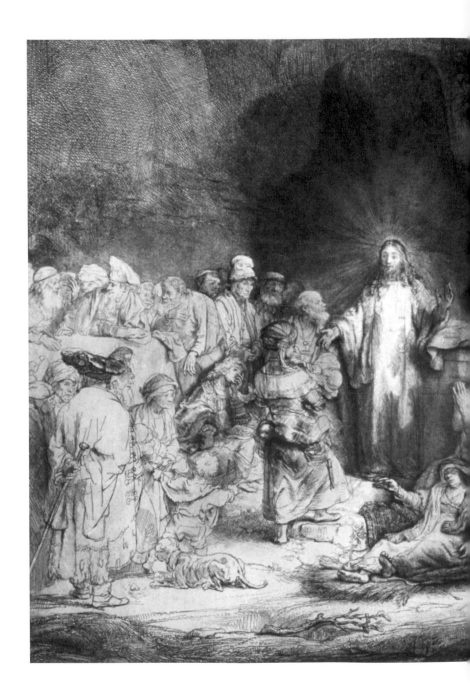

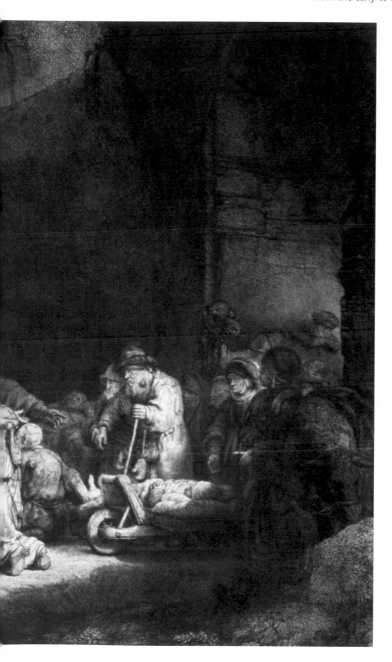

Christ Healing the Sick, one of Rembrandt's most famous etchings from the early to mid 1640s.

no mustard. Six told the servant to go into the village and buy some. Knowing that it would be an hour before he came back, Rembrandt bet Six that he could etch a copper plate before the servant returned, and he etched the view from the window, which became *Six's Bridge*.

OUTCASTS

Despite the wealth of the Netherlands, large numbers of people lived in poverty. Many who came to Amsterdam to start a new life struggled to make a living to survive. In Leiden, for example, textile workers often lived in atrocious conditions. So bad was the poverty that it was common for orphans, and other children, to be sent to work in the mills.

In the late 1620s Rembrandt produced a number of small etchings of outcasts and beggars, the kind of people who were to crop up later as part of the crowd in paintings such as *Christ and the Woman Taken in Adultery*. His keen eye for observation captured perfectly not only their desperate plight but also their humanity. He also etched a number of self-portraits in the late 1620s and 1630s, depicting himself with

The Three Trees, Rembrandt's largest
etching, 1643.

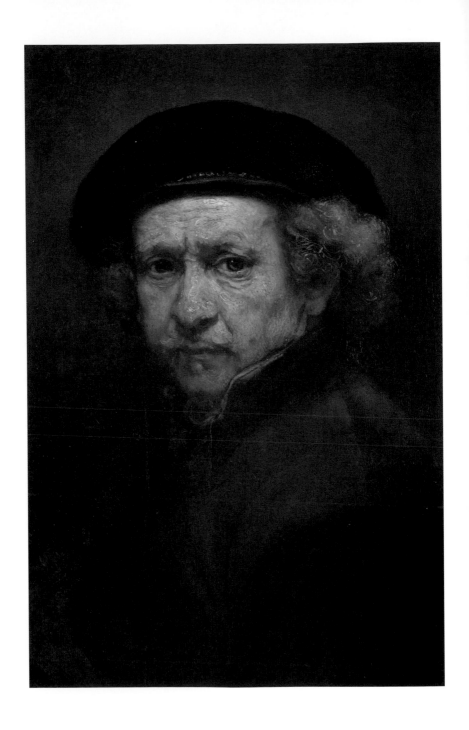

a variety of expressions: angry, laughing, wild and even as a beggar himself.

In 1648 Rembrandt produced an etching of himself drawing at a window. Wearing a hat and his work clothes, he sits with his pen poised over a sheath of papers. But he looks anxious and unhappy. This was the period in which he was caught up in the dispute with Geertje Dircx. Still, the face that stares out from the etching is a dignified one, even defiant. Rembrandt appears to have had a pragmatic approach to life. Or rather he saw his life as part of a bigger picture, one in which an unseen presence was at work.

Chapter 9

THE RETURN OF THE PRODIGAL SON

Amsterdam's reputation as one of the great cities of Europe had continued to grow throughout the seventeenth century. And it had further been enhanced since the independence of the Netherlands had been recognized even by Spain in 1648. The city fathers believed that its status as the capital of the official new republic, and its political and economic power, needed to be reflected in a majestic and imposing new town hall to replace the one ravaged by fire in 1637.

When Rembrandt heard that a commission was to be given to a painter to produce a series of large paintings for the town hall, he must have thought he stood a good chance of securing it. Things were looking up. A major commission such as this would not only provide a much-needed boost to his finances following his bankruptcy but also reaffirm his reputation as one of the Netherlands' leading painters.

But, despite his reputation as a big-name painter, the city fathers overlooked him. It was his ex-pupil Flinck who once again proved to be the man of the moment. He was asked to provide eight paintings depicting the Roman historian Tacitus' account of the revolt of the Batavians, a people who once inhabited the Netherlands, against the Romans in the first century. The city fathers saw parallels between the Batavians' struggle against Roman power and the Netherlands' struggle for independence from Spanish rule. They viewed themselves as the descendants of this ancient people.

However, Flinck hadn't been working on the series long when he died suddenly, in 1660. The commission was then given to three painters: Jan Lievens, Jacob Jordaens, whose previous commissions included *The Triumph of Frederik Hendrik* for the court at The Hague, and Rembrandt. Rembrandt

was asked to paint a meeting of various tribes, gathered around their leader Claudius Civilis, swearing an oath. He must have been delighted to be back in favour with the Amsterdam political worthies.

When he had completed the painting, *The Conspiracy of Julius Claudius Civilis*, in late 1661, it was hung in the town hall's gallery. At 6 m by 6 m it must have looked spectacular. The painting portrays Claudius Civilis at a midnight banquet with his followers, who swear an oath to defeat Rome. It bursts with potential dark deeds and violence. Rembrandt's use of glowing orange and yellow creates the image of a fire, which heightens the brooding atmosphere, and perhaps even carries within it echoes of hell. The one-eyed Civilis sits at the table, his broadsword joined menacingly with those of the brutish warriors at his side. Simon Schama describes it as 'one of the most revolutionary acts of painting in the entire history of seventeenth-century art'. He adds, 'No one, not Rubens, not Titian, had ever painted quite like this.'

But that's not how the city fathers saw it. They didn't like it. What happened then is unclear, but it seems Rembrandt was told to take the painting back and make some changes to it. The reason for this may have been that Rembrandt failed to present the figures in the kind of dignified and romantic light that the city fathers had expected, and that, presumably, Flinck would have done. Rembrandt's painting was too crude and violent for their taste. He had portrayed their ancestors as barbarians. Some have suggested that the swearing of the oath with swords was an invention of Rembrandt. And he had also portrayed Claudius wearing a crown, which went against the whole idea of a republic.

Rembrandt had no choice but to take the picture back home, where he cut it down to a smaller size and retouched it. Despite these changes,

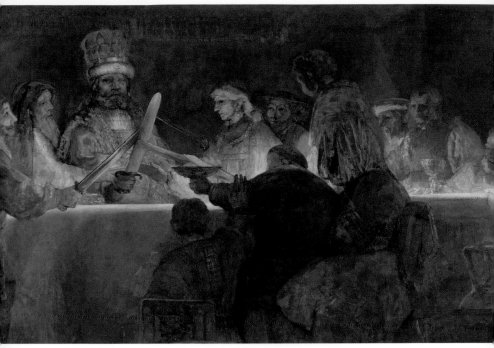

however, the city fathers still rejected it, and brought in another artist to complete the painting Flinck had begun.

Simon Schama sees *Claudius Civilis* as a painting 'drunk on its own wildness', and one that would not just be the ruin of Rembrandt's comeback, but also the ruin of his greatest vision, for what survives today, he maintains, is just a fifth of the original size.

Rembrandt's relationships with his wealthy patrons have been much debated over the years. Did he mix in their circles? Or did he keep his distance? The evidence would suggest that he was a bit of a loner and not someone who felt naturally at home making small talk among the great and the good. He seemed to prefer to spend his time in his studio or with his family. When the Brotherhood of Painters was formed in Amsterdam in the 1650s, to bring together painters and writers, Rembrandt didn't join. His former pupil Flinck did, and this could be why he, and not Rembrandt, was originally commissioned to provide paintings for the city's new town hall.

In *The Anatomy Lesson of Dr Nicolaes Tulp* of 1632 and *The Night Watch* ten years later, Rembrandt had attempted to revolutionize the group

The Conspiracy of Julius Claudius Civilis, 1661,
was hung in Amsterdam's town hall.

portrait. After the success of these paintings, we might have expected him to receive a number of such lucrative commissions. But, apart from *The Anatomy Lesson of Dr Deyden* in 1656, for some reason they didn't materialize.

Around the same time as he was commissioned to paint *The Conspiracy of Claudius Civilis*, Rembrandt was also approached by the drapers' guild, who had the job of controlling the quality of blue and black cloth produced in Amsterdam. He produced *The Sampling Officials of the Drapers' Guild*. The officials are dressed in black suits with white collars and wearing black hats. They are shown sitting around a table covered with a Persian rug and on which a book is open. A sixth man is getting up. They are depicted looking straight at the viewer. Rembrandt had produced a more traditional group portrait, and this time his patrons were happy.

Rembrandt now had a unique and recognizable style. His paintings often had dark, almost muddy backgrounds, with the main characters picked out by light. He had begun his career painting in bright colours, then he had moved to softer colours, and now his palette was deeper and richer. Dark red, brown and golden yellow were some of those he favoured most.

According to Simon Schama, Rembrandt made paint itself the subject of the paintings he did in his last decade. His paint handling 'went off to lead a life of its own; an amazing vagabond life of daubing, dragging, twisting, dabbing, drizzling, coating, sloshing-into-wet, kneading, scraping, building into monumental constructions of pigment that had the mass and worked density of sculpture, yet which shone with emotive illumination'.

THE JORDAAN DISTRICT

Rembrandt, Hendrickje, Titus and Cornelia were now living in a rented house on the Rozengracht, the rose canal, in a district called the Jordaan, a much less fashionable area than the Breestraat. They lived opposite an amusement park, which attracted large crowds from across the city. With plenty of drink available, fights sometimes broke out. On one occasion, Hendrickje was summoned with some of her neighbours – a sailor's widow, the wife of a gold-wire maker and an innkeeper – to give evidence in a case involving a drunken surgeon who was accused of threatening passers-by.

The Jordaan was becoming popular with artists, who were unable to pay the higher rents in areas such as the Breestraat. By coincidence, Jan Lievens was also living on the Rozengracht. It had been forty years since he and Rembrandt had both set out as eager young artists in Leiden to make their names. Govaert Flinck had also lived there.

Because of his bankruptcy, legally Rembrandt was supposed to give any money he made from selling his art to his creditors. To get around this, he formed a company with Titus and Hendrickje. He became their advisor, for which he received a salary, a room

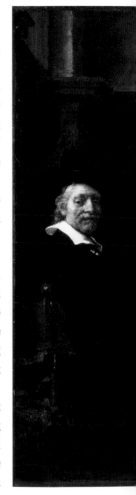

The Sampling Officials of the Drapers' Guild, 1662

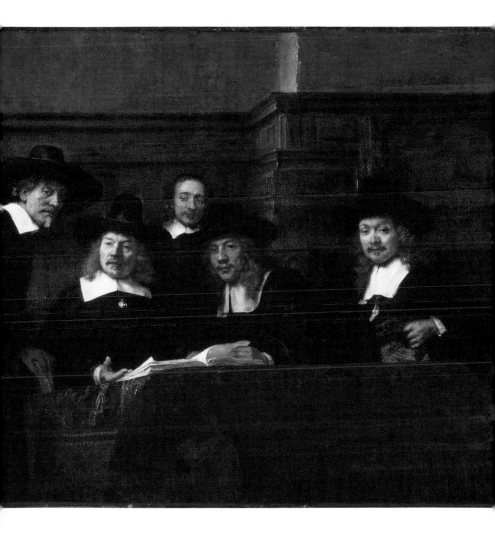

THE RETURN OF THE PRODIGAL SON

155

and board and also spending money. In December 1660 Rembrandt, Hendrickje and Titus appeared before a notary to officially form their business partnership. They were chartered to trade in 'paintings, graphic arts, engravings, and woodcuts, as well as prints, curios, and all related objects'.

All Rembrandt's possessions now legally belonged to his son and common-law wife, who were entitled to share equally the profits from the business. In reality, of course, all this was just a legal technicality. Rembrandt was the boss.

He was now free to concentrate on painting without worrying about losing his home and paying those he owed money to. Between 1656 and 1660, while under the jurisdiction of the Insolvency Court, he had painted very little, but his output now increased. He began turning out paintings at a similar rate to that of the early 1630s. And he returned to portraits. For example, he painted Jacob Trip, who had made his fortune in iron, tar and the arms trade, and his wife, Marguerite de Geer, as well as Lieven Wilemszoon van Coppenol, a teacher and calligrapher.

Rembrandt also painted a portrait of one of his friends, Jeremias de Decker, whom he had known since his early days as an artist in Leiden. He was a poet, though not a very successful one, and he had written poems about Rembrandt's *The Risen Christ Appearing to Mary Magdalene*.

Other portrait commissions came from Aert de Gelder, a former pupil who was one of Rembrandt's greatest admirers (he is shown holding a copy of *The Hundred Guilder Print*), and Gerard de Lairesse, a fellow painter whose face was disfigured, possibly by syphilis. The Lutheran merchant

Frederick Rihel is depicted riding a horse, in what was Rembrandt's largest painting since *The Night Watch*.

Fittingly, the last pictures Rembrandt painted are some of his most tender. In *The Jewish Bride*, he depicts a man and a woman dressed in rich clothes. The man is placing his hand gently on the breast of the woman. Some think it is a double portrait of the Jewish poet Don Miguel de Barros and his wife Abigail de Pina; others see it as a representation of the biblical characters Isaac and Rebecca, or Jacob and Rachel. It has even been suggested that the couple are King Cyrus of Persia and the shepherdess Aspasia, or maybe even Titus and his wife.

Christopher White speaks for many critics when he says of this painting, 'It is work of utmost simplicity and represents one of the greatest expressions of the tender fusion of spiritual and physical love in the history of painting. Probably, more tellingly than any other work, it demonstrates Rembrandt's capacity to isolate the essence of a story and immortalise it devoid of the specific connotations of a particular story.'

He goes on to highlight how Rembrandt has created 'intimacy and poetry' by the warmth of the colours he uses beneath the glowing light. 'His golden sleeve is contrasted with the ample expanse of the red of her dress, with her sleeves echoing the colour of his tunic. The background of architecture and landscape is a neutral green and brown. The paint applied layer upon layer with both the brush and the palette knife miraculously suggests the depth of feeling inherent in the picture.'

When Vincent van Gogh saw the painting in the Rijksmuseum in 1885 he said, 'I should be happy to give ten years of my life if I could go on sitting in front of this picture for ten days with only a dry crust of bread.'

In his later years, Rembrandt painted a number of pictures of Titus and Hendrickje. We have already mentioned *Titus at His Desk.* In 1660 he produced *Titus Reading* and *A Young Monk* (for which Titus modelled). Titus also seems to have tried his hand at painting, as the inventory from Rembrandt's bankruptcy shows, but appears not to have had much success. But we know that he was promoting his father's work. In 1665 he travelled to England to negotiate a deal with a publisher to commission Rembrandt to do a book illustration. When the publisher questioned whether Rembrandt could make a good engraving, as opposed to an etching, Titus is said to have replied, 'My father can engrave with the best of them.' Some have suggested that Rembrandt travelled to the English port of Hull in around 1661 or 1662 to paint the seafarers there. But there seems to be no solid evidence for this. Neither is there any substance to the suggestion that he visited London and Windsor during his days working in Leiden.

Rembrandt painted several pictures of Hendrickje, including *Hendrickje at an Open Door* in 1656. She is also thought to be the model for *Portrait of a Young Woman, Juno, Bathsheba Holding King David's Letter* and possibly, say some historians, *A Woman Bathing.*

But it's Rembrandt's 1654 portrait of Hendrickje that G. Baldwin Brown sees as a masterpiece, putting it alongside Leonardo's *Mona Lisa* and Titian's *Lady with a Mirror.* He says of it:

> *As if the artist had been conscious of the future destiny of his picture he has imparted to it more of that comeliness*

The Jewish Bride, c. 1666, one of Rembrandt's
last paintings.

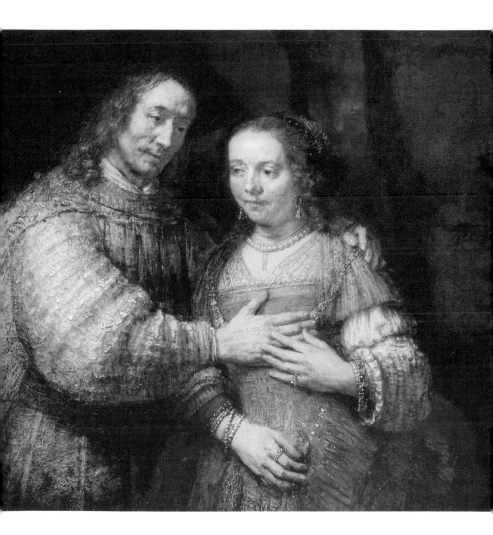

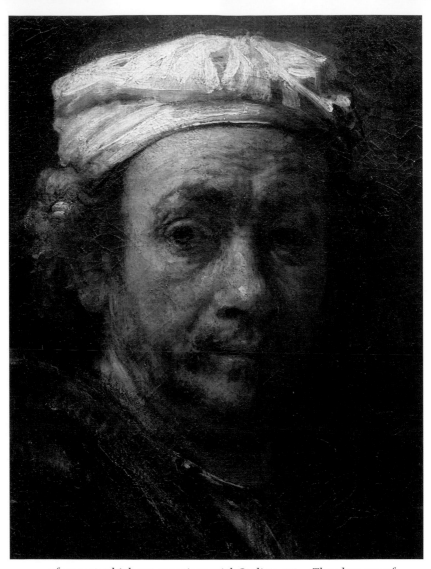

of aspect which we associate with Italian art... The glamour of the jewels that flash here and there in dress or hair, the gradual growing-out of the largely moulded plastic form from the darkness, the amber and gold that flood the scene and almost banish local differences of hue – all of these are Rembrandt's own, and they give the key-note to the whole impressionist school, that looks to Rembrandt as to one of its heads.

Self-portrait, 1660, sees Rembrandt dressed as a working artist.

Rembrandt had started out doing self-portraits in his studio in Leiden and in the last decade of his life he returned to himself as a subject. His self-portrait of 1660 shows him dressed as a working artist, holding his palette and brushes. His hair is white and his expression is thoughtful and dignified. But there is contentment about him. In 1661 he depicted himself as St Paul, one of his favourite biblical figures. His self-portrait of 1669 shows him looking more insecure, as if he is, as one art historian put it, 'being honest with himself in the morning mirror'. Showing that he still had a sense of fun, that same year he also painted himself laughing in *Self-portrait as Zeuxis*, which recalls the painting he did of himself and Saskia in 1635.

THE PRODIGAL SON

Some art historians think that during the last decade of his life, Rembrandt turned increasingly away from the outside world and retreated into his own world. There is some truth in this, but that isn't to say he became a recluse. Apart from his art, he had a young mistress, a son and a small daughter. And he must have had a circle of close friends. His life would have been very full.

In some of Rembrandt's paintings from the 1660s, such as *Jacob Wrestling with the Angel* and *Moses with the Tablets of the Law*, we can see moments of grace or, if you prefer, of hope and change. In fact, these can be seen not just in the paintings from his final years but throughout his career, not least in his biblical pictures.

One painting from the 1660s that, more than any other, displays Rembrandt's fascination with the idea of grace is *The Return of the Prodigal*

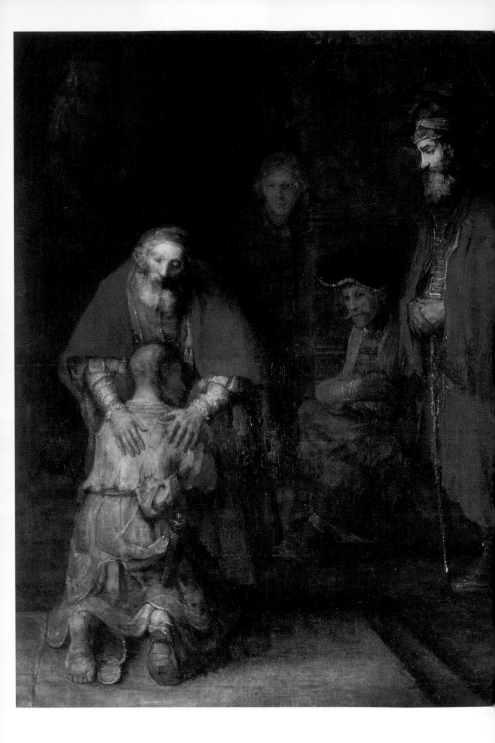

Son, dated 1665, one of the last pictures he painted. Kenneth Clark suggests that those who have seen the original, now in the Hermitage in St Petersburg, may be forgiven for claiming it 'as the greatest picture ever painted'.

The painting tells the story, from Luke's Gospel, of a young man who leaves home for a foreign land, where he squanders his share of his father's property on women and drink. He then returns home penniless, broken and ashamed. Instead of berating him, his father throws a party, much to the anger of the older son who has remained at home and been hard-working and dutiful. The father acknowledges this, but tells him that it is only right to hold a celebration because his brother had been lost but is now found.

In *The Return of the Prodigal Son: A Story of a Homecoming,* the Dutch Roman Catholic priest and author Henri J. M. Nouwen talks about the impact the painting had on his life. He first came across it on a large poster pinned to a door in the office of the L'Arche home for adults with learning difficulties where he was working in the French village of Trosly.

'I could not take my eyes away,' he recalls. 'I felt drawn by the intimacy between the two figures, the warm red of the man's cloak, the golden yellow of the boy's tunic, and the mysterious light engulfing them both. But, most of all, it was the hands – the old man's hands – as they touched the boy's shoulders that reached me in a place I had never been reached before.'

In 1983 Nouwen unexpectedly got an opportunity to see the painting when he was invited by friends on a trip to the Soviet Union. Sitting in front

*Could it be that Rembrandt
identified with the prodigal son,
as Nouwen goes on to suggest?*

of the real thing, which measures 262 cm high by 206 cm wide, he says its majestic beauty stunned him. He writes, 'There had been moments in which I had wondered whether the real painting might disappoint me. The opposite was true. Its grandeur and splendour made everything recede into the background and held me completely captivated.'

Could it be that Rembrandt identified with the prodigal son, as Nouwen goes on to suggest? After all, he had painted a portrait of himself with Saskia in 1635 in which he looked every inch the reckless, brash, self-confident man about town. Nouwen even suggests that the picture is set in one of Amsterdam's many brothels.

Yet, despite this, on the face of it, Rembrandt doesn't seem to have lived what might be called a wild life. He didn't have a reputation as a drunkard or philanderer. On the other hand, he'd spent lavishly on collecting art and curiosities – money that he couldn't always afford, as his bankruptcy proved. Furthermore, he'd had an affair with Geertje and then had her sent to a house of correction because he had begun a relationship with Hendrickje. Moreover, he'd shown himself not to be above some dodgy business practices. He was a complex man.

In the twilight years of his life he might have reflected back over some of his actions and felt his soul to be troubled. While he seems to have remained on the fringes of the church, he was clearly a deeply spiritual man and one who was steeped in the Bible.

Nouwen says, 'As I look at the prodigal son kneeling before his father and pressing his face against his chest, I cannot but see there the once so self-confident and venerated artist who has come to the painful realization that all the glory he had gathered for himself proved to be vain glory.' Instead

of the rich garments in which the youthful Rembrandt painted himself, Nouwen goes on, he now wears a torn tunic and worn-out sandals.

Commenting on Rembrandt's 1654 *Flora*, modelled by Saskia, Walter Liedtke notes a sadness in her face that was absent in his earlier treatment of the subject. He concludes, 'it's a goddess of spring who knows that fall is coming. You can see it in her expression. Flowers, beauty, youth, don't last.'

INTERNATIONAL REPUTATION

Rembrandt's reputation had spread far beyond the Netherlands. In 1654 he had sold a painting of *Aristotle Contemplating the Bust of Homer* to the wealthy Sicilian Don Antonio Ruffo, who had a collection of paintings from across Europe. Rembrandt charged 500 guilders, far more than an Italian master would have asked, and more than Rembrandt would have got from a Dutch collector.

In 1661 Don Antonio asked Rembrandt to provide a companion painting to hang alongside Homer. Rembrandt sent him a painting of Alexander the Great along with another of Homer. But Don Antonio was not pleased with what Rembrandt sent him and wrote to his agent in Amsterdam, telling him to make his views known to Rembrandt. He claimed the picture 'was painted with four pieces of canvas sewn together. These four seams are horrible beyond words. Besides, in time they will crack and consequently the canvas as a whole will be ruined.' He said the Alexander was only a head and the Homer wasn't finished.

Rembrandt is reported to have replied that a painting 'is completed when the master has achieved his intention by it'. Nevertheless, Rembrandt

did retouch the Homer. The disagreement over these paintings did not destroy the business relationship between Rembrandt and Don Antonio. Such was Rembrandt's reputation as a master etcher that it might well have been his etchings that originally brought him to the attention of his patron. In any case, Don Antonio was a big fan of the style of Rembrandt's etchings – in 1669 he ordered 189 of them.

Rembrandt's fame abroad continued to grow, even if he had been eclipsed by the new wave of painters – Johannes Vermeer, Jan Steen, Pieter de Hoogh – who were now dominating the art market in the Netherlands. The Grand Duke Cosimo III de Medici went to see Rembrandt when he visited Amsterdam in 1667, and Cardinal Leopold de Medici commissioned him to paint a self-portrait for his collection.

DEATH

In the 1660s a plague swept through Amsterdam and much of Europe, claiming thousands of lives, including Hendrickje's in 1663. She was buried in an unmarked, rented grave in the Westerkerk.

Rembrandt, aged fifty-seven, was now left to care for their thirteen-year-old daughter Cornelia alone. Money was still a problem for him, which was why, in 1662, he had sold Saskia's grave in the Oude Kerk to a gravedigger. Because of the plague, the city was running out of space to bury the rising numbers of dead.

In 1668 Titus married Magdalena van Loo, a niece of Saskia's older sister Hiskia, and they moved in with her mother in a house in the Apple Market. Their joy was short-lived, however, as the plague also claimed Titus

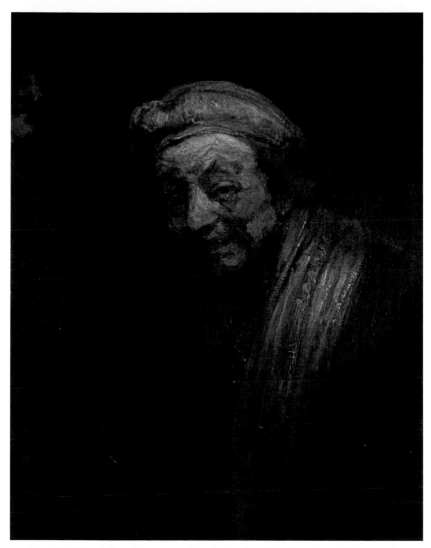

and he died the following year, shortly before his daughter Titia was born. He was buried, like Hendrickje, in a rented grave in the Westerkerk.

The deaths of Rembrandt's two loved ones, coming so quickly one after the other, might well have reminded him of that tragic period in the 1630s when three of his children died within a few years of each other.

But Rembrandt didn't outlive Hendrickje and Titus for long. He died on 4 October 1669, aged sixty-three. We have no details of his death, but he, too, may have been claimed by the plague. He was also buried in the

Westerkerk. The day after his death an inventory of his possessions was drawn up. It consisted of just 50 items – not many compared to the 363 items listed in the inventory drawn up at the time of his bankruptcy – mainly furniture, household effects and paintings. Magdalena ordered some of the property to be locked away. An unfinished painting of Simeon in the Temple was found in his studio.

Magdalena too died just a few weeks later, possibly yet another victim of the plague. The following year, Cornelia married an artist, Cornelis Suythof, and they went to live in Java, in the Dutch East Indies, where they had two children – named Rembrandt and Hendrickje.

Chapter 10
THE SUPERSTAR

I n 2008 Rembrandt hit the headlines when what was believed to be one of his self-portraits from the late 1620s was sold to an anonymous bidder for £2.2 million at the Moore, Allen and Innocent auction house in the market town of Cirencester in Gloucestershire. The painting, known as *Rembrandt Laughing* and signed RHL, had been valued in the auction catalogue at up to £1,500. The head auctioneer, Philip Allwood, told *The Guardian* that the atmosphere in the saleroom was electric. 'Once the price went above £1 million the whole place fell silent. When it topped £2 million you could hear a pin drop. Once the hammer went down, the whole place erupted in applause.'

The paintings of a man who struggled with his finances for much of his life, and eventually went bankrupt, are now a sure-fire way for others to make a fortune. Rembrandt is big business.

Following his death in 1669, the debate began about how good a painter Rembrandt really was. In 1708, when the French academic Roger de Piles compiled a league table of major artists, giving them points for composition, drawing, colour and expression, Rembrandt only came tenth out of fifty-seven. And for drawing, he received only six points out of a possible twenty. Michelangelo, on the other hand, scored seventeen.

But in the nineteenth century, French artists rallied around Rembrandt as a symbol of democracy, seeing him as a true romantic, a man of the people – unlike Rubens, for example, whose fame depended on the patronage of royalty and the church. The artist and critic Eugène Fromentin described him in glowing terms as a deeply spiritual painter. In the Netherlands Rembrandt was proclaimed as one of the country's

great figures, and in 1852 the civic authorities in Amsterdam erected a monument to him on Rembrandtplatz.

What is and what isn't a painting by Rembrandt is controversial and has been hotly disputed among art experts over the years. One of the reasons why there have been so many disputes is that his students often made copies of his works. And in the case of his drawings, it's likely that they would have taken unfinished ones he had thrown away to complete.

Rembrandt Laughing was given the seal of approval by the Rembrandt Research Project (RRP), an Amsterdam-based organization set up in 1968 to classify all Rembrandt's known paintings. It claims that there are around 300 confirmed Rembrandt paintings in the world today. A century ago there were believed to be nearly 1,000. To reach its decisions, the RRP employs all the latest technology, including X-rays, and carries out forensic investigations into works thought to be by Rembrandt.

But not everyone is willing to fall in with the RRP's judgments, especially museum curators who not only pride themselves on their knowledge of art but are also anxious to protect the reputation of their institutions. No one likes being made to look a fool.

In a 2005 publication the RRP suggested that a portrait, *Rembrandt as a Young Man*, in Liverpool's Walker Art Gallery might not be a self-portrait by Rembrandt but a work by Isaac Jouderville. This conclusion was based on a comparison in the style of brush work between the Walker Gallery's portrait, painted on wood, and a much smaller Rembrandt self-portrait, painted on copper, in the National Museum, Stockholm.

The Walker Gallery curators dismissed the RRP's conclusions, claiming that it was not possible to make such a firm judgment on its

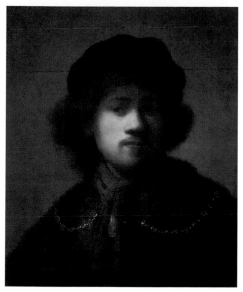

Possibly *Self-Portrait as a Young Man,* c. 1630.

painting, which is covered in a heavy, discoloured varnish that obscures both original brushstrokes and old retouchings, and has probably not been cleaned for at least half a century. They also pointed out that the only known signed portrait by Jouderville, in the National Gallery of Ireland, Dublin, is significantly different in style.

The disputed painting has been in the Walker's collection since 1953 and was first described as a self-portrait by Rembrandt in the inventory of King Charles I's paintings, compiled around 1639, when the painting hung in Whitehall Palace. It is thought to have been part of a gift from Prince Frederik Hendrik's Dutch court to Charles I, and was delivered to him by the king's envoy, Sir Robert Kerr.

In defending their painting's authenticity, the Walker Gallery pointed out that when the RRP attributed Rembrandt's painting *An Old Woman,* part of the Royal Collection in London, to Jan Lievens, British Rembrandt scholars rejected their view, arguing that the painting was indeed genuine.

The National Gallery in London, by contrast, now no longer lists *A Man Seated Reading at a Table in a Lofty Room,* thought to have been painted in Leiden in the late 1620s, as a Rembrandt but as a 'follower of Rembrandt'.

Writing in *Time* magazine in 1992, the art critic Robert Hughes went to what he saw as the heart of the problem over establishing authentic Rembrandt works. 'Unlike Rubens, Rembrandt was not particularly scrupulous about saying which pictures were entirely by him and which

were done in part by assistants, and the result – coupled with the fact that when his reputation recovered from its short eclipse after his death, everyone who owned a brown luminous seventeenth-century Dutch portrait wanted it to be by Rembrandt – has been a web of confusion.'

He goes on to attack the RRP for giving its seal of approval to paintings 'that no one with half an eye' could mistake for genuine Rembrandts, such as the *Feast of Esther*, generally attributed to Jan Lievens, and also for rejecting other paintings, such as *The Man with the Golden Helmet*, which he believes are genuine.

Key to deciding whether or not a Rembrandt work is genuine is his signature. French art historian Jean-Marie Clarke maintains that Rembrandt became Rembrandt in 1633, after a year of trying out different signatures. He claims that in 1632 he used three signatures, changing twice: from the monogram RHL to RHL-van Rijn, and from that to Rembrant. In 1633, he added a 'd' to create Rembrandt.

There have been works by Rembrandt that have fetched far more at auction than *Rembrandt Laughing*. In 1998 *Portrait of a Bearded Man in a Red Coat* was sold at Sotheby's in New York for £6.27 million.

A new record price was set for a Rembrandt in 2003 when a self-portrait, which lay undiscovered for centuries after it had been painted over, sold for £6.94 million at an auction at Sotheby's in London. It was bought by the billionaire casino tycoon Steve Wynn from Las Vegas.

The picture had originally been thought to not be a self-portrait by Rembrandt but a painting of a Russian nobleman. While the portrait resembled Rembrandt and bore his signature, researchers had previously dismissed it as not genuine because it seemed to lack the artist's technical

A Man Seated Reading at a Table in a Lofty Room, c. 1631–50 described as having been painted by a 'follower of Rembrandt'. Image is © National Gallery.

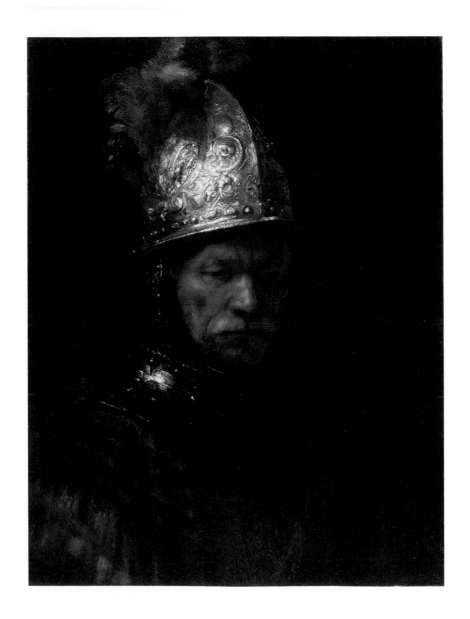

The Man with the Golden Helmet, believed to be a genuine Rembrandt painting.

skills. But art restorers working for the RRP concluded that the painting was indeed a Rembrandt after spending six years painstakingly scraping away layers of paint that had been added. The painting is thought to have been painted over by one of Rembrandt's students and recycled. The pupil added earrings, a goatee beard, shoulder-length hair and a velvet cap to make it appear to be a Russian aristocrat.

There are said to be more than 150,000 paintings in public ownership in the UK, but not all of them are on display. The Public Catalogue Foundation, which catalogues all the paintings in public ownership, held by schools, council offices, museums, hospitals and fire stations, believes that about 80 per cent of these paintings are being left to gather dust in cupboards and attics, and that among them are likely to be works by some of the great masters. This was indeed the case with a Rembrandt which was discovered in a broom cupboard at a London hospital. The staff had no idea that the room where they kept their mops also contained such a valuable piece of art.

In 2000 a painting entitled *Portrait of a Lady* was sold at Christie's in London for £19.8 million, the highest price ever paid for a Rembrandt. The painting, part of a sale of the collection of the late Baroness Batsheva de Rothschild, had been expected to sell for between £4 million and £6 million.

It was bought by Robert Noortmann, who owns a gallery in Maastricht. He told the Associated Press that he was proud to be bringing the masterpiece back to the Netherlands, and that he had fallen in love with the elderly woman who was its subject. 'You can tell that the woman in this painting must have been someone Rembrandt really liked, because it is so

intimate. I fell in love with her even though she's meant to be sixty-two –
and my wife didn't even mind.'

But Rembrandt has a long way to go if he is to catch up with his
Flemish hero Peter Paul Rubens. In 2002 Rubens' long lost painting
The Massacre of the Innocents was sold at Sotheby's in London for nearly
£50 million, becoming the most expensive painting in Britain. The
painting was discovered hanging in a corridor in an Austrian monastery,
where its owner had asked the monks to look after it – because she disliked
it so much.

There is another problem in authenticating Rembrandts: forgery.
Because a Rembrandt is worth big money, many forgers have used their
skills to try to hoodwink the art world. For example, according to New
York Customs, a total of 9,428 Rembrandts were imported to the United
States between 1909 and 1951.

One of the most bizarre cases occurred in 2004 in St Louis, USA,
when a man dressed as a sheikh, posing as a member of the Saudi royal
family, and his female accomplice, a former art dealer, tried to sell a
forgery of *The Man with the Golden Helmet* for $2.8 million to a buyer
in a hotel. The buyer turned out to be an undercover FBI agent and the
pair were arrested and later jailed. In the 1980s *The Man with the Golden
Helmet*, which hangs in a Berlin museum, had been declared not to be
an authentic Rembrandt, though Robert Hughes has refused to agree
with this.

Forgeries are bad for the art business, points out Theodore
Stebbins, curator of American art at Harvard University's Fogg Museum,
because once they are accepted, then it lowers the perceived quality of

art. 'If more and more forged Rembrandts are out there, they don't look very good compared to a real Rembrandt. Pretty soon our feeling is that Rembrandt is not a good painter. It changes our view of the artist and in the end diminishes it. It's potentially damaging to all of art, to people who care about art.'

THEFTS

It is not just forgeries that have dragged Rembrandt's name into the criminal world. He has also been the target of armed robbers. In 1975 his 1632 painting *Portrait of a Girl Wearing a Gold-Trimmed Cloak* was stolen from the Museum of Fine Arts in Boston, USA, when two men purchased tickets to the museum and then set about removing the painting from the wall. When a guard ordered them to stop, one of the men pulled out a pistol and hit him. Police recovered the painting the following year after a clandestine operation in the car park of a Boston restaurant.

Boston was the scene of another art heist in 1990, and Rembrandt was again a target, when two men dressed as police officers carried out

the world's largest, and also most baffling, art robbery, recounted in *Loot: Inside the World of Stolen Art* by Thomas McShane and Dary Matera.

The audacious duo turned up at the city's Isabella Stewart Gardner Museum and told security guards they were investigating a disturbance by teenagers. They then handcuffed the guards, took them to the basement and trussed them up with duct tape. The thieves removed the video from the surveillance recorder, turned the first-floor camera away from the security desk, and tore off and removed a computer printout that reported all the alarm and door activity.

Slipping through the elaborate security system, the thieves made their way to the Dutch Gallery on the second floor. They then set to work removing four works by Rembrandt, *A Lady and Gentleman in Black*, *Christ in the Storm on the Sea of Galilee*, a self-portrait and an etching. The men attempted to take another self-portrait, but when they prised it from the wall they realized it was painted not on canvas but on wood, so it couldn't be cut from the frame and rolled up. They also took a painting by Vermeer, a landscape by Govaert Flinck that had formerly been attributed to Rembrandt, and a 3,000-year-old Chinese beaker. The men then went to another room and took works by Dégas and a painting by Manet.

The eleven works were valued at an estimated $200 million. But art experts and investigators were puzzled by some of the works the men had chosen to steal. They had ignored Titian's *The Rape of Europa*, possibly worth $300 million, and paintings by other masters such as Raphael, and instead opted for a number of pieces of art whose value in comparison was small. At the time of writing, the thieves have never been caught and none of the works they stole has ever been recovered.

The world's most stolen painting is thought to be a Rembrandt, the small portrait Jacob de Gheyn III... *Over the last forty years it has been stolen four times, giving it the nickname 'the takeaway Rembrandt'.*

In 2000 an even more daring raid took place when armed robbers with pistols and sub-machine-guns burst into the National Museum in Stockholm, Sweden, and snatched a self-portrait by Rembrandt, along with two small Renoir paintings. They then made their getaway in a speedboat moored in a nearby waterway. The painting was recovered five years later in Copenhagen when Danish police arrested four men during an operation at a hotel in the city.

The world's most stolen painting is thought to be a Rembrandt, the small portrait *Jacob de Gheyn III*, which hangs in the Dulwich Picture Gallery in south London. Over the last forty years it has been stolen four times, giving it the nickname 'the takeaway Rembrandt'. It has been recovered every time. On one occasion it was found on the back of a bicycle, and on another underneath a bench in a graveyard.

REMBRANDT AROUND THE WORLD

Rembrandt's paintings can be viewed in seventeen countries. The largest collections are held in Staatliche Museen, Berlin; the Louvre, Paris; the Rijksmuseum, Amsterdam; the Mauritshuis in The Hague; and the National Gallery in London. His works can also be found in Russia, Switzerland, Sweden, Belgium, Hungary, Australia, Ireland, Scotland, Spain, the United States, Canada, Japan, Italy, Poland, Denmark, Finland, Portugal, Czech Republic and Austria.

Rembrandt's popularity has continued to grow. When the National Gallery in London held an exhibition of seventeenth-century Dutch art in 1976 it included more paintings by Rembrandt than by Vermeer, Frans

Thought to be the world's most stolen painting, *Jacob de Gheyn III.*

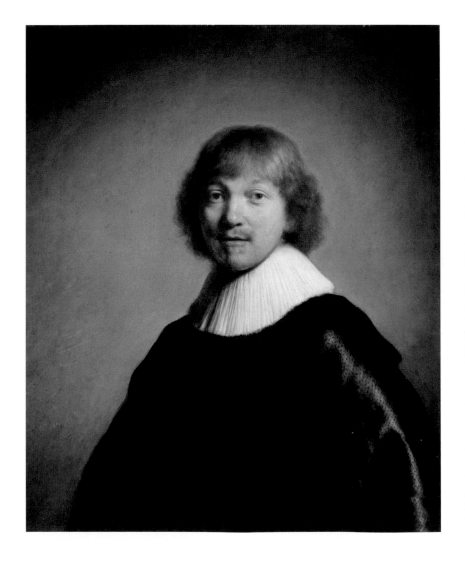

Hals, Gerard ter Borch, Pieter de Hoogh or any other artist. This was, said Christopher Brown, because he 'was the greatest of all seventeenth-century Dutch painters'.

In 2006 celebrations were held around the world to commemorate the 400th anniversary of Rembrandt's birth. And, as you would expect, the Netherlands led the way. His home town of Leiden hosted a festival during which seventeenth-century food and drink were served in restaurants and entertainers performed street theatre.

In Amsterdam they did things on a much bigger scale. Museums in the city held fifteen themed exhibitions to reflect different aspects of his work. These included 'Rembrandt the Observer' at the Rijksmuseum, 'The Jewish Rembrandt' at the Jewish Historical Museum, 'Rembrandt and Uylenburgh' at the Rembrandthuis – the house where Rembrandt lived for much of his life before his bankruptcy. The Van Gogh Museum staged an exhibition bringing together Rembrandt and Caravaggio. And, confirming his superstar status, the Royal Theatre Carre put on *Rembrandt the Musical*.

When the Metropolitan Museum of Art in New York held an exhibition featuring 228 seventeenth-century Dutch paintings in 2007/2008, it called it not 'The Age of Vermeer' or 'The Age of Van Dyck' but 'The Age of Rembrandt'. And during the European Fine Art Fair in the small Dutch city of Maastricht in 2001, the headline in *The New York Times* ran, 'Rembrandt Is the Star at the Fair'. For the 200 art and antique dealers from 13 countries who turned up at the world's largest art fair the undisputed star of the show, according to reporter Carol Vogel, was Rembrandt's *Portrait of a Lady*, which, as we have seen, had sold for £19.8 million the year before.

A group of children view Rembrandt's
The Night Watch at the Rijksmuseum
in Amsterdam.

THE LEGACY

Although some of Rembrandt's portraits might no longer be fashionable,
the artist himself has remained so. But while art historians wax lyrical
about *The Night Watch*, I suspect that many people nowadays find some of
Rembrandt's other works more appealing. For all its technical brilliance,
The Night Watch doesn't contain the kind of humanity or tenderness that
Rembrandt managed to capture in, for example, *Christ and the Woman Taken
in Adultery*, *The Jewish Bride* or *The Return of the Prodigal Son*. Nor does it
have the visual power of *Belshazzar's Feast*.

Charles L. Mee says:

> *With everything he did, Rembrandt stirred things up. First, and almost
> astonishingly to his contemporaries, he mixed his categories – doing
> portraits as though they were history paintings and history paintings
> as though they were genre paintings of everyday life. Just as he did the
> group portrait of Dr Tulp as though it were a dramatic painting rather
> than a group portrait, so he would put low life into high drama. He
> would slip a bit of lewd sex into a scene that was meant to be prim, a few
> swilling drunks into a solemn biblical story. He would put real emotions
> and recognizable people into the past, something of the exotic into the
> familiar and something of the familiar into the exotic.*

Despite his personal tragedies; his rancorous legal battles with his former
lover Geertje; the humiliation of his bankruptcy and the loss of his house
and possessions; his falling out with Huygens and his disappointments
and failures over the passion series for Prince Frederik Hendrik; and the

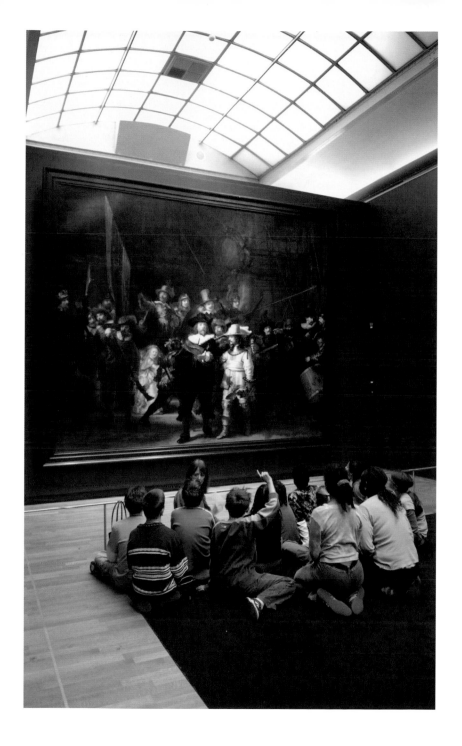

rejection of *The Conspiracy of Julius Claudius Civilis*, Rembrandt stayed true to his calling. And his calling was to use his extraordinary gifts as an artist to present us not just with wonderful paintings, drawings and etchings but with penetrating observations of human life and, more than that, with hints of something he believed lay beyond the visible world.

Bibliography

Alpers, Svetlana, *Rembrandt's Enterprise: The Studio and the Market*, London, Thames and Hudson, 1988.

Art in Seventeenth Century Holland, London: National Gallery, 1976.

Baldwin Brown, G., *Rembrandt: A Study of His Life and Work*, London: Duckworth, 1907.

Bomford, David, Jo Kirby, Ashok Roy, Axel Ruger and Raymond White, *Art in the Making: Rembrandt*, London: National Gallery, 2006.

Brown, Christopher, *Dutch Painting*, Oxford: Phaidon, 1976.

Clark, Kenneth, *An Introduction to Rembrandt*, London: John Murray, 1978.

Gombrich, E. H., *The Story of Art*, Oxford: Phaidon, 1984.

Haak, Bob, *Rembrandt Drawings*, London: Thames and Hudson, 1976.

Kitson, Michael, *Rembrandt*, Oxford: Phaidon, 1969.

MacCulloch, Diarmaid, *Reformation: Europe's House Divided, 1490–1700*, Harmondsworth: Penguin, 2004

Mannering, Douglas, *The Life and Works of Rembrandt*, Bath: Parragon, 1994.

McCall Smith, Alexander, introduction, *BP Portrait Award 2008*, London: National Portrait Gallery, 2008.

McShane, Thomas and Matera, Dary, *Loot: Inside the World of Stolen Art*, Maverick House, 2007

Mee, Charles L., *Rembrandt's Portraits: A Biography*, New York: Simon and Schuster, 1988.

Nouwen, Henri, *The Return of the Prodigal Son: The Story of a Homecoming*, London: Darton, Longman and Todd, 1994.

Puppi, Lionello, *Rembrandt*, London: Thames and Hudson, 1969.

Schama, Simon, *Rembrandt's Eyes*, London: Allen Lane, 1999.

Schwartz, Gary, *Rembrandt: His Life, His Paintings*, London: Penguin, 1985.

Slatkes, Leonard J., introduction and commentaries, *Rembrandt*, New York: Abbeville Press, 1980.

Slive, Seymour, *Rembrandt (1606–1669)*, London: Collins, 1961.

Wallace, Robert and others (eds), *The World of Rembrandt, 1606–1669*, Amsterdam: Time-Life International, 1968.

Westermann, Mariet, *The Art of the Dutch Republic 1585–1717*, London: Laurence King, 1996.

White, Christopher, *Rembrandt*, London: Thames and Hudson, 1984.

Useful web sites

www.artbible.info

www.rembrandtpainting.net

www.nationalgallery.org

www.rijksmuseum.nl

www.holland.com

www.rembrandtresearchproject.org

www.rembrandthius.nl

General Index

Index of Rembrandt's works

Bold type indicates the page on which a painting, drawing or etching is reproduced

Picture Acknowledgments

Alamy: pp. 19, 20, 56, 73, 84, 103, 113, 125, 159 The London Art Archive; pp. 34, 80, 104, 108 The Print Collector; pp. 41, 135 INTERFOTO Pressebildagentur; p. 47 Tony Cunningham, p. 183 Rolf Adlercreutz

Corbis: pp. 3, 53, 79, 89, 109, 148 Francis G. Mayer; p. 15 Jon Hicks; p. 37 Araldo de Luca; p. 45 Atlantide Phototravel; pp. 50, 144–45 Burstein Collection; p. 63 Boris Roessler/dpa, pp. 71, 141, 147 Historical Picture Archive, pp. 94, 162 The Gallery Collection; p. 142 Bettmann

Dulwich Picture Gallery: pp. 87, 180 By Permission of the Trustees of Dulwich Picture Gallery

Getty: pp. 77, 139, 152, 160, 167 The Bridgeman Art Library; p. 116 Time & Life Pictures

Jon Arnold Images: p. 78 © Walter Bibikow / Jon Arnold Images

Musée des Beaux Arts, Lyon: p. 33 © MBA Lyon / Photo Alain Basset

Museum of Fine Arts, Boston: p. 42 Rembrandt Harmensz. van Rijn, Dutch, 1606–1669 Artist in His Studio, about 1628. Oil on panel. 24.8 x 31.7 cm (9 3/4 x 12 1/2 in.). Museum of Fine Arts, Boston. Zoe Oliver Sherman Collection given in memory of Lillie Oliver Poor 38.1838 Photograph © 2009 Museum of Fine Arts, Boston.

National Gallery: p. 173 A Man Seated Reading at a Table in a Lofty Room, Web NG Number: NG3214, Artist: Follower of REMBRANDT © The National Gallery, London

Scala: pp. 29, 54 (both images) © 2008 White Images/Scala Florence; p. 39 © 1999 Photo Musee Jacquemart Andre/ Inst. De France/Scala, Florence; pp. 60, 68, 155 (2008), 72, 174 (2005), 92 (2007) © Photo Scala, Florence/BPK, Bildagentur fuer Kunst, Kultur und Geschichte, Berlin; pp. 74 (2007), 96(2006) © Photo Austrian Archive/ Scala Florence; p. 111 © 2007 Image copyright The Metropolitan Museum of Art/Art Resource/ Scala, Florence

Topfoto: p. 132 The Granger Collection; p. 177 www.topfoto.co.uk

Walker Gallery: p. 171 © National Museums Liverpool, Walker Art Gallery

Lion Hudson

Commissioning Editor: Kate Kirkpatrick

Project Editor: Miranda Powell

Designer: Nicholas Rous

Picture Researcher: Jenny Ward

Production Manager: Kylie Ord

Know what? You're in a vicious circle

When you feel low, you tend to stop doing things. You don't go out so much, you avoid seeing friends and you even stop listening to music or watching sport.

As a result, you feel even lower, and then you feel like doing even less. It can seem such relief to cut down and withdraw. It's tempting to take to bed, or sit or lie around all day. But if you do, you end up all seized up, feeling stiff, tired and overwhelmed.

It's like: the less you do, the worse you feel, the worse you feel, the less you do. And it keeps going round and round and round…

Things can get quite vicious.

So, what's going on?

1 **Symptoms make things hard.**
Low, not sleeping/tired.
Scared, fed up.
Can't be bothered.

4 **Count the cost.**
Feel worse, lose confidence.
Less pleasure, less achievement,
see friends less.
You feel worse and worse.

2 Struggle to do things.
Everything seems harder/more effort.
Things seem pointless/not enjoyed.
Going through the motions.

**3 Cut down/avoid things
that seem too hard.**
Do less and less.
Only do things you must/
should do.
"You" time squeezed out.

Turn over to break the circle

DO YOU KNOW WHAT YOU JUST DID?

You broke
the circle

WELL DONE!

All it took was a little bit of positive action - turning that page in this case.

Now all you have to do is take another tiny step, then another and another.

What steps? That's what this book is about – to show you the easy steps you can take to break that circle into bits and start feeling better.

It involves making choices. Choosing to do things that make you feel better, rather than hiding away feeling worse and worse.

Important question coming up

WHAT DOES YOUR DAY LOOK LIKE?

When things seem hard, it's easy to lose your previous routine. It's tempting to lie in bed longer, stay up later, or have a longer nap each afternoon. But before you know it you lose the pattern and structure of your day.

What times do you typically get up?

...and go to bed?

These are the anchors that start and end your day.
Other anchors that split your day are mealtimes.
So, when do you eat?

Breakfast

Lunch

Tea/dinner

Around these points are all the other activities of the day.
Meeting friends, household chores and more.
You need to get a routine going again. And start building in activities that you know are good for you.

First, look at what you do just now

Think about yesterday

Start by thinking about the last 24 hours. Write down everything you have done. Include things like getting dressed, talking to a friend on the phone, washing your hair, etc. Then score them out of ten for pleasure, achievement and feeling close to other people. The first few spaces are filled in to show you how to do it. Doing this will help you understand what's good in your life and also to realise what's missing.

About closeness

Feeling close to others is really important, but when we're down, we sometimes hide away. If your diary doesn't have enough things with a good closeness score, this book will help you sort that out.

	Pleasure	Achievement	Closeness
Talking to Alison on the phone.	9	3	10
Cleaning my room.	1	10	0

	Pleasure	Achievement	Closeness
	☐	☐	☐
	☐	☐	☐
	☐	☐	☐
	☐	☐	☐
	☐	☐	☐
	☐	☐	☐
	☐	☐	☐
	☐	☐	☐
	☐	☐	☐
	☐	☐	☐
	☐	☐	☐
	☐	☐	☐
	☐	☐	☐
	☐	☐	☐
	☐	☐	☐
	☐	☐	☐

Check your list and pick out the things
you did that scored highly for pleasure,
achievement or closeness to others.
Write them down here.

11

ANYTHING MISSING FROM YOUR DAY?

What about things you've stopped doing?

Your day might not have contained all the things you like to do, so have a look through the list below and tick the one's that apply to you. Things you used to enjoy but haven't felt like doing lately.

Enjoying sport. ☐
Seeing your friends. ☐
Listening to music. ☐
Watching a film. ☐
Pursuing a hobby. ☐
Watching TV. ☐
Phoning or texting friends. ☐
Gardening/looking after plants. ☐
Going for a walk/Getting some fresh air. ☐
Doing exercise. ☐
Going to a class or club. ☐
Playing a musical instrument. ☐
Reading a good book, magazine or blog. ☐
Practicing relaxation techniques. ☐
Doing drama. ☐
Going to church, mosque, temple or synagogue. ☐
Spending time with family. ☐
Cooking or baking for pleasure. ☐
Helping other people. ☐

Well ticked!

Now choose an activity you want to do

USE WHAT YOU'VE FOUND TO START FILLING YOUR DAY WITH GOOD STUFF

Remember, the things that make you smile.

One of the reasons we feel worse when we stop doing things, is the fact that it's usually the things we like that we avoid first.
No wonder life seems to go down and down!

To start it going up again, you need to pick good things to fill your day with. Not all the time – just one thing to start with. So the next step of your plan is to look at the lists you just made and pick one of the things on them.

Pick something that used to give you pleasure, or a sense of achievement. Or something that you think is worthwhile or made you feel close to others.

Just one thing to start with.

An activity you value and see as important to your life.

NOW WRITE IT HERE IN BIG LETTERS SO YOU DON'T FORGET IT.

GOOD

You've just written down the thing you're going to start doing again. Something worth getting up for.

Now, you're going to do it

NOW PLAN
WHEN
YOU'LL
DO IT

Say what
and when

Think about the activity you want to do first.

Write down *what* you will do, and *when* you will do it into the Activity Planner on the next two pages.

Just now it will stand out as the only activity there.

Go, ahead, write it in.

You don't want it to feel lonely, so soon you'll be adding other activities into the Activity Planner.

But to start with just include:

- The single activity you planned - the one you wrote down on page 15.
- Add your daily anchors: the meals you have through the day, and the time you get up and go to bed.

There's plenty of time to add more activities, but for now just focus on the first activity you're going to do.

MY ACTIVITY PLANNER

Plan a balance of activities over the days and week.

Get into a routine- a time to get up, eat, go to bed, and do the household chores, or perhaps to go for a walk, meet friends or attend a regular class.

Choose things you Value and give a sense of Pleasure, Achievement or Closeness.

Plan in the key essentials that otherwise will build up and cause you problems- paying bills, cutting the lawn, doing the washing up, ironing, having a hair cut etc.

Build things up over a few weeks so you end up with one activity planned in each part of the day. Leave some gaps for the unexpected things that crop up. Have some time just for you.

	Morning	Afternoon	Evening
Monday			
Tuesday			
Wednesday			
Thursday			
Friday			
Saturday			
Sunday			

Now build on it

REMEMBER THAT LONELY ACTIVITY?

Now let's give it some friends

Add some more regular activities

Having to get out of bed to walk the dog or feed the baby can be a real pain, especially on cold mornings, but it's also a great way to feel better. No dog? No baby? Then make yourself a routine with other things. Shaving and showering. Cleaning the house. Popping to the corner shop to say hello and buy some bacon and eggs. Cooking them for breakfast! Can't get out? Make the most of activities you can do.

And if you rebuild your routine with things that involve others (ringing your mum each morning, walking with a friend every Wednesday) you'll feel even better because of that closeness thing we mentioned before.

It needs to be a daily routine, too. Choose something every single day that you need to get up and out of bed for. Don't lie in - remember, the less you do the worse you feel, the worse you feel, the less you do. Add these to your Activity Planner.

More Good stuff on the next page

ADD SOME MORE OF THE GOOD STUFF

Plan a series of other activities, then add them one by one into your Activity Planner. Make each activity small and not scary. Don't be ambitious, be easy on yourself. And don't worry if you have to keep crossing things out, there's plenty of space.

- Choose some of the good stuff that helps how you feel.

- Add in some of the things you've cut down or stopped doing that used to be good too.

- Choose things you value and give a sense of pleasure, achievement or closeness.

- Build things up over a few weeks so you end up with one activity planned in each part of the day.

With each activity you add, you're breaking that vicious circle, and making it spin the other way so you feel better and better.

Are you ignoring important things?

Some activities may seem hard or boring. Paying the bills, looking after yourself, keeping up with the housework - they can all seem too much trouble when you're feeling down.

The problem is some activities are necessary, and if you don't do them it makes you feel worse and can get you in a mess. So here's what to do: choose one thing that wasn't in your diary but should have been, and plan to do it - now.

Pay that bill. Make that call. Get your hair done. Do some tidying. Wash the dishes.

You'll feel loads better afterwards and you'll be able to add it to your diary and put a 10 in the 'achievement' box!

Aim for the following

You know what makes you feel good.

Across each day and week you need to get a mix of activities that help.

Start with the activities you can change most easily.
Aim for variety so you address each of the key areas:

1. Pleasure - things that makc you feel good.
2. Achievement: things you value and see as important.
3. Closeness: where you connect with important others.
4. Finally don't forget to do things that are important and necessary.

Each of these activities breaks the vicious circle and makes you feel better. But don't rush. Some activities need to be built up to slowly.

TAKING STEPS THAT MOVE YOU FORWARDS

Some activities may be good for you, but seem just too hard to do all at once. You need to work up to doing them step by step.

How?

Have a look at the example opposite.

For example

Jack used to like meeting his friends for a walk in the park, but since he's been low, he hasn't had the energy for it. This is what he wrote in his plan for getting back to meeting them.

Step 1. Go to the park and just sit there enjoying the peace and quiet.

Step 2. Go back to the park and walk by myself. Don't need to talk to anyone if I don't feel like it.

Step 3. Get into the habit of walking by myself 2 or 3 times a week.

Step 4. Get in touch with one friend and arrange to have a walk and a chat.

Step 5. Go to the park with my friend at a time when we're likely to see the others.

Step 6. Arrange to meet the others next time they're walking in the park.

Step 7. Keep going – get into a routine and feel the difference!

Jack knew he could take one step a day, or one step a week, it didn't matter. What mattered was having a plan and making steady progress towards getting some fun back in his life.

Right, that's enough of Jack. Now back to your plan.

WRITE DOWN AN ACTIVITY THAT YOU NEED TO BUILD UP TO STEP BY STEP HERE

Now think about the little steps you can take towards doing it. Don't be overly ambitious, be easy on yourself. And don't worry if you have to keep crossing things out, there's plenty of space.

1. I'm going to _____

2. Then I'm going to _____

3. Next, I'm going to _____

4. Then I'm going to _____

5. _____

6. _____

7. _____

8. _____

9. _____

10. _____

SOUNDS EASY DOESN'T IT?

But you know change sometimes isn't that easy

Remember all those failed New Year's resolutions? Promises to change that seem hard. Or maybe we forget, or find we can't be bothered, or talk ourselves out of things.

So, let's recognise something. It's hard to make changes. That's why we've asked you to pick activities to do that you know can be good for you.

But if you find you get stuck doing a particular activity, here's a helping hand to make a plan to do it that will work.

Turn over to make your plan.

DON'T JUST SIT THERE, MAKE A PLAN!

1. WHAT AM I GOING TO DO?

2. WHEN AM I GOING TO DO IT?

3. WHAT PROBLEMS OR DIFFICULTIES COULD ARISE, AND HOW CAN I OVERCOME THEM?

Is my planned task

Q. USEFUL FOR UNDERSTANDING
OR CHANGING HOW I AM?

YES ☐ NO ☐

Q. SPECIFIC, SO THAT I WILL
KNOW WHEN I HAVE DONE IT?

YES ☐ NO ☐

Q. REALISTIC, PRACTICAL
AND ACHIEVABLE?

YES ☐ NO ☐

MY NOTES

HOW DID IT GO?

Life's all about learning

If you make a plan and everything goes smoothly- that's great!

But you can also learn a lot from when things go wrong too. So, if there are problems with your plan- that's great too. It's great because you can play detective and learn. So, if you got stuck, or something was difficult, ask yourself some questions. Was the problem something *internal* – inside you, or *external* – for example a problem caused by someone else, the weather, or unexpected circumstances?
Use whatever you discover to make your next plan even better.

You'll find a useful Review sheet to help you with this learning on the next two pages.
Try to get into a sequence of *Plan* (using the Planner sheet), *Do*, and *Review* (using the Review sheet) for whenever you are planning more difficult activities. That way you will keep moving forwards.

OK, HOW DID IT GO?

WHAT DID YOU PLAN TO DO?
WRITE IT HERE

DID YOU TRY TO DO IT?

YES	NO

IF YES:
1. WHAT WENT WELL?

2. WHAT DIDN'T GO SO WELL?

3. WHAT HAVE YOU LEARNED FROM WHAT HAPPENED?

4. HOW ARE YOU GOING TO APPLY WHAT YOU HAVE LEARNED?

IF NO: WHAT STOPPED YOU?

INTERNAL THINGS
(FORGOT, NOT ENOUGH TIME, PUT IT OFF, DIDN'T THINK I COULD DO IT, COULDN'T SEE THE POINT ETC.).

EXTERNAL THINGS
(OTHER PEOPLE, WORK OR HOME ISSUES ETC.).

HOW COULD YOU HAVE PLANNED TO TACKLE THESE THINGS?

WHAT IF SOMETHING GOT IN YOUR WAY?

Learn from it. So as soon as you've written your next plan, think about what could stop it happening. Are there things that might trip you up? What about other people? Could someone be unhelpful at any stage?

When you've figured out what could block your progress, work out another mini-plan for getting around the obstacle. It's called unblocking.

Things to watch out for

Don't try and make every change possible all at once.

Be realistic – you're planning for success not a let-down. You know your own personality and how inpatient or ambitious you are. That's where it's important to be wise and plan just one main change a day to start with.

So, pick just a few things to get you started, and make a separate plan to do each using the Planner sheet. Then plan them in across the day and the week using the Activity Planner.

1. Leave some gaps for the unexpected things that crop up.
2. Include some time just for you.
3. Remember the anchors - a time to get up, eat, go to bed.
4. Add in some more routines like a regular time to do the household chores, or perhaps to go for a walk, meet friends or attend a regular class.
5. Make sure your plan fits with your values/ideals of how you want to live.

But don't forget that some things are important to do even if they aren't much fun or seem difficult.

AT THE END OF EACH DAY

Use your Happy List to help you remember

Each evening, sit down and write down three things that you:

- Have enjoyed.
- Felt was a job well done.
- Or helped you feel close to someone else.

After a few days, you'll have a list of great things that you can look back on. It will help you remember how you're changing things.

Time to give yourself a pat on the back!

WHERE TO GET EVEN MORE HELP

Sometimes it can seem too difficult to start getting going again, even with small steps. That's when you need a bit more help than this little book can give.

You can get it at the Living Life to the Full course (www.llttf.com) where you'll connect with other people who feel like you, and find out how to contact professionals who can help you make changes in your life.